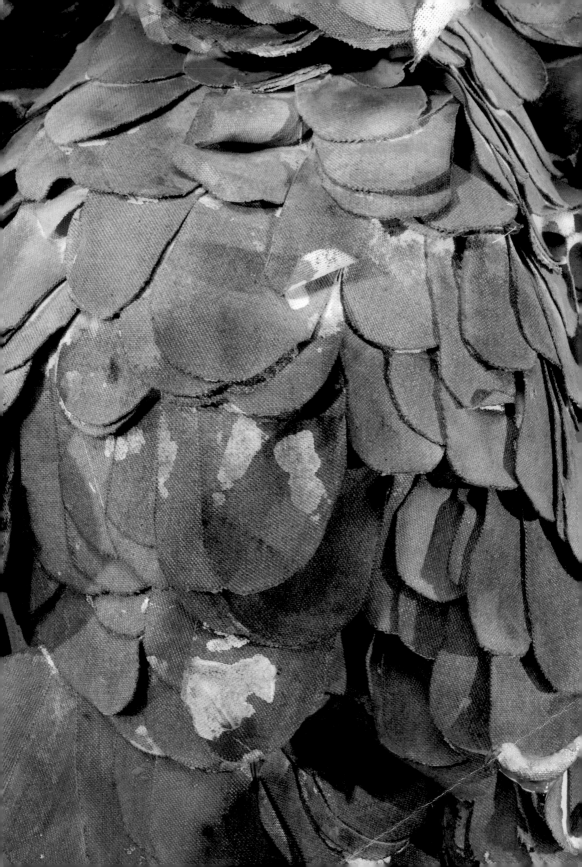

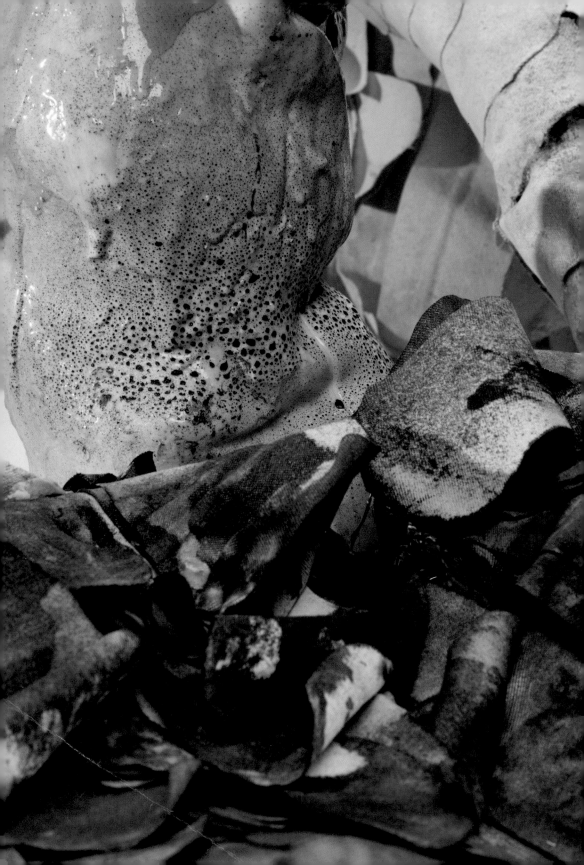

NATHALIE DJURBERG WITH MUSIC BY HANS BERG

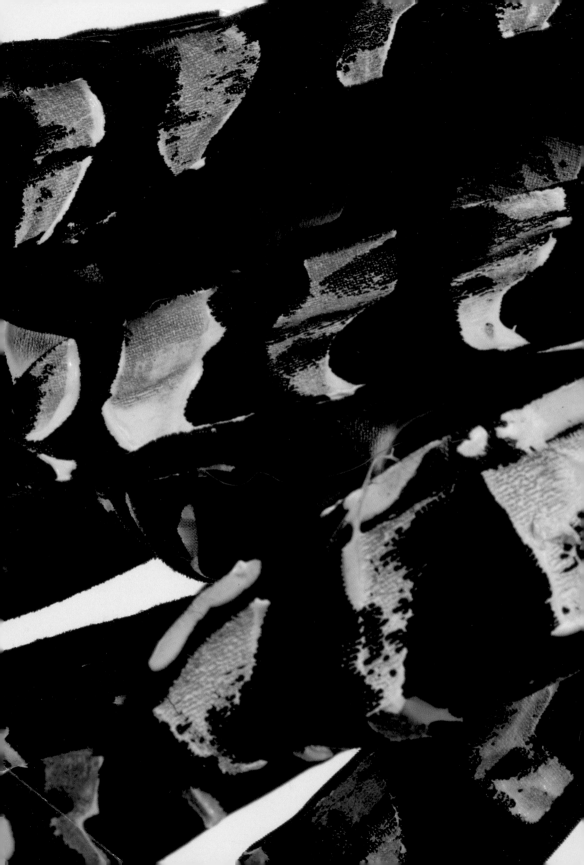

with music by

Nathalie Djurberg

Hans Berg

THE PARADE

Walker Art Center
Minneapolis

Published on the occasion of the exhibition *The Parade: Nathalie Djurberg with Music by Hans Berg*, organized by Eric Crosby and Dean Otto for the Walker Art Center, Minneapolis, Minnesota.

Walker Art Center
Minneapolis, Minnesota
September 8–December 31, 2011

New Museum
New York, New York
May 11–July 8, 2012

Yerba Buena Center for the Arts
San Francisco, California
October 13, 2012–January 27, 2013

The Parade: Nathalie Djurberg with Music by Hans Berg is made possible by generous support from Miriam and Erwin Kelen. Additional support is provided by Iaspis, the Swedish Arts Grants Committee's International Programme for Visual Artists.

The exhibition catalogue is made possible by a grant from the Andrew W. Mellon Foundation in support of Walker Art Center publications. Additional support for the catalogue is generously provided by Zach Feuer Gallery, New York, and Galleria Giò Marconi, Milan.

Library of Congress Cataloging-in-Publication Data

Djurberg, Nathalie, 1978-
 The Parade : Nathalie Djurberg with Music by Hans Berg / edited by Eric Crosby and Dean Otto.—1st ed.
 p. cm.
 Published on the occasion of an exhibition held at the Walker Art Center, Minneapolis, Minn., Sept. 8–Dec. 31, 2011, the New Museum, New York, N.Y., May 11–July 8, 2012 and the Yerba Buena Center for the Arts, San Francisco, Calif., Oct. 13, 2012–Jan. 27, 2013.
 ISBN 978-1-935963-04-2
 1. Djurberg, Nathalie, 1978- Parade—Exhibitions. 2. Birds in art—Exhibitions. 3. Installations (Art)—Exhibitions. I. Berg, Hans, 1978- II. Crosby, Eric, 1980- III. Otto, Dean, 1966- IV. Walker Art Center. V. New Museum (New York, N.Y.) VI. Yerba Buena Center for the Arts. VII. Title. VIII. Title: Nathalie Djurberg with Music by Hans Berg.

 N7093.D58A73 2011
 709.2—dc23
 2011030183

Available through D.A.P./Distributed Art Publishers, 155 Sixth Avenue, New York, NY 10013. www.artbook.com

Design Director
Emmet Byrne

Designer
Dante Hong Carlos

Editors
Kathleen McLean and Pamela Johnson

Senior Imaging Specialist
Greg Beckel

Printed in the United States by Bolger, Inc., Minneapolis, Minnesota

Typeface: Organda and URW Grotesk
Paper: Sappi Flo

Contents

Over the past decade, Nathalie Djurberg has transported us through her remarkable films and objects to worlds where fantasy, anxiety, and taboo coexist. Her practice—which merges animated film, performance, sculpture, and installation—exudes a palpable sense of freedom and bold originality, both in the way she employs and transforms materials and in her fiercely intelligent treatment of her subjects. These aspects of her art come to life even more when set to the densely layered music of her collaborator, Hans Berg. Since 2004, they have produced a singular body of work that is as moving as it is provocative.

It is our privilege at the Walker Art Center to initiate and organize this major touring exhibition of the artists' most recent project, perhaps their most complex and fascinating installation to date. Inspired by the natural history of birds—their evolution and physiology, their mating rituals, and the social phenomenon of flocking—*The Parade* includes more than eighty freestanding, handmade bird sculptures constructed of wire, foam, clay, painted fabric, and myriad other materials, as well as five new claymation films set to an immersive and haunting soundtrack by Berg. We are also honored to work with the artists on this publication, which documents their collaboration so vividly and presents texts that tease out the installation's many elusive meanings.

As a multidisciplinary institution, the Walker is committed to supporting the work of young artists such as Djurberg and Berg, who think across multiple evolving platforms of expression. It was therefore fitting that the show's organizers—visual arts curatorial assistant Eric Crosby and film/video associate curator Dean Otto—would bring their respective disciplines to bear on this production. They have worked closely with Djurberg and Berg to assemble an installation that beautifully highlights the artists' already ample achievements and remarkable voices. The curators' insightful contributions to this publication have made the project richer still.

We extend thanks first and foremost to Nathalie Djurberg and Hans Berg, who opened their studio and home to Crosby and Otto and allowed the curatorial process to unfold as the project itself developed. Their engagement and spirit of generosity have been exceptional, as has been the support of Darsie

Alexander, the Walker's chief curator, who initiated this unique collaboration. The works in the show come to us from the artists, courtesy of their gallerists Zach Feuer in New York and Giò Marconi in Milan. We thank both for their advocacy of the exhibition and their support for this publication.

This installation has been made possible through the generosity of Miriam and Erwin Kelen, longtime supporters of the Walker, and Iaspis, the Swedish Arts Grants Committee's International Programme for Visual Artists. We are grateful to both for their early commitment to the project. We are delighted that Djurberg and Berg's first major US show will continue on a national tour following its presentation at the Walker. We thank the New Museum in New York and its director, Lisa Phillips, and Yerba Buena Center for the Arts in San Francisco and its director, Kenneth J. Foster.

The Parade marks Djurberg's continued exploration of all modes of transformation: material, psychological, sexual, evolutionary, and otherwise. It also signals a new direction for Berg's compositions. With their most recent films, they have begun to reinvent their storytelling, allowing characters, situations, and sounds to freely migrate across forms. Such echoes—from one narrative to the next, from the sculptural to the cinematic, from the animal kingdom to the human unconscious—invite us to see our own world anew.

13

Olga Viso
Executive Director, Walker Art Center

Acknowledgments

In bringing this project to fruition, we must first thank two very talented and committed artists. It has been a great pleasure to work closely with our friends Nathalie and Hans on this exhibition, its tour, and this publication. Their generosity and collaborative spirit inspire us. At Zach Feuer Gallery, New York, we thank Zach for his cooperation and kind support, as well as gallery director Grace Evans, who deftly handled logistical matters every step of the way.

At the Walker, executive director Olga Viso and chief curator Darsie Alexander were enormously supportive of the project from its inception and advocated for its book and national tour. Curator Siri Engberg provided crucial guidance as this catalogue developed. Assistant director of exhibitions Lynn Dierks and visual arts assistant DeAnn Thyse coordinated many aspects of the project, most crucially early development of the exhibition tour. Our thanks also go to our colleagues in the visual arts and film/video departments for their ongoing support: Clara Kim, Elizabeth Carpenter, Sheryl Mousley, Bartholomew Ryan, Camille Washington, and Jenny Jones.

This singular book is the impeccable work of senior designer Dante Carlos, who responded to Nathalie's parade with sensitivity, creativity, and good humor. Chief of communications and audience engagement Andrew Blauvelt and design director Emmet Byrne oversaw the project with assistance from Dylan Cole. Editors Kathleen McLean and Pamela Johnson expertly tracked the book to its completion, bringing their nimble way with words and production schedules to every facet of the process. Walker photographer Cameron Wittig coordinated an ambitious shoot, opening his studio to more than eighty wild creatures, and senior imaging specialist Greg Beckel skillfully polished many of the pictures. In the library and archive, Rosemary Furtak, Jill Vuchetich, and Barbara Economon provided valuable research materials throughout the essay's development, and assistant registrar Pamela Caserta advised on reproduction rights.

To transform the Walker's Burnet Gallery into another world was no small feat, and it required the dedication of many. Program services director Cameron Zebrun and his team of technicians, led by Kirk McCall, installed the work with utmost

grace and understanding. The generosity of McCall's guidance in all matters of exhibition-making is matched only by his kindness, and Peter Murphy's sensitivity to audio-visual installation is unparalleled. Assistant registrar Jessica Rolland fastidiously oversaw the safe packing and transport of this delicate work, a process that began under the watchful eye of registrar Joseph King. Registration technician David Bartley and frame shop supervisor Scott Lewis tended to the creatures upon arrival.

In the development office, Christopher Stevens, Marla Stack, and Annie Schmidt worked to secure key funding for the project, while CFO Mary Polta and chief of operations and administration Phillip Bahar offered fiscal and executive oversight. Ryan French and his marketing team, including Adrienne Wiseman and Julie Caniglia, ensured that this work had a visible presence beyond the Walker's walls. Christopher James ably handled the press, securing wide interest for *The Parade* in the Twin Cities and around the country. In the education and community programs department, Sarah Schultz, Ashley Duffalo, and Susy Bielak coordinated an array of programs around the show, while Courtney Gerber assembled a team of tour guides able to tackle its difficult themes with visitors. Finally, John Lindell and Todd Gregory in building operations kept the flock safe while on view at the Walker.

We also join our director in thanking our tour partners. Massimiliano Gioni, director of exhibitions at the New Museum, expressed early interest in the show. With the oversight of deputy director John Hatfield and associate curator Gary Carrion-Murayari, we are thrilled that this exhibition will be realized in New York. It is only fitting that it then migrate to Yerba Buena Center for the Arts in San Francisco, and for that we thank Betti-Sue Hertz, director of visual arts, and Amy Owen, senior exhibitions manager. Both institutions are committed to showcasing the work of today's most compelling artists across disciplines, and we sincerely appreciate their partnership.

Eric Crosby, Curatorial Assistant, Visual Arts
Dean Otto, Associate Curator, Film and Video

16

THE PARADE

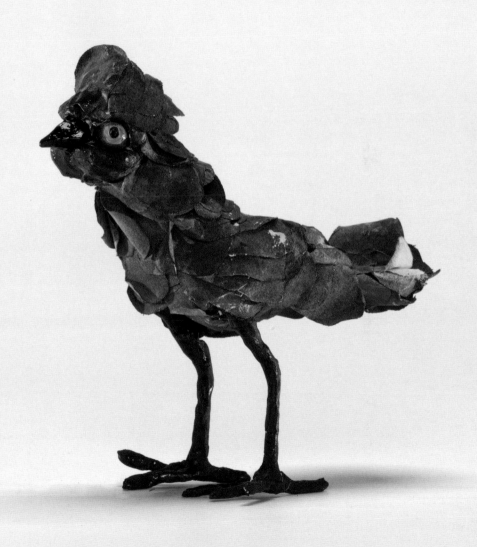

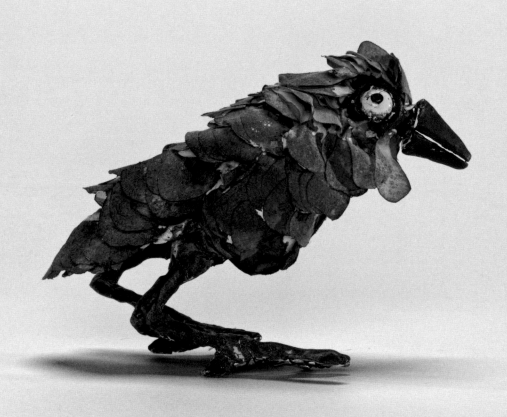

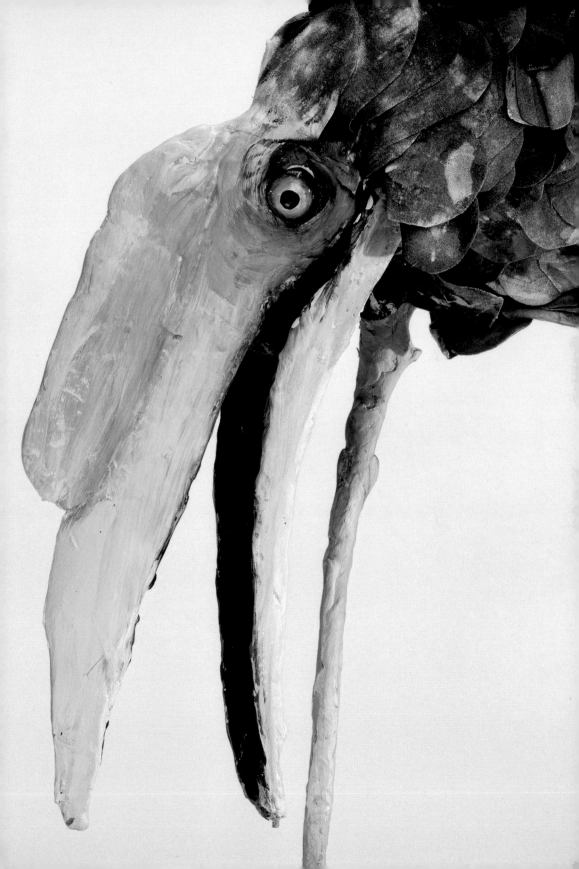

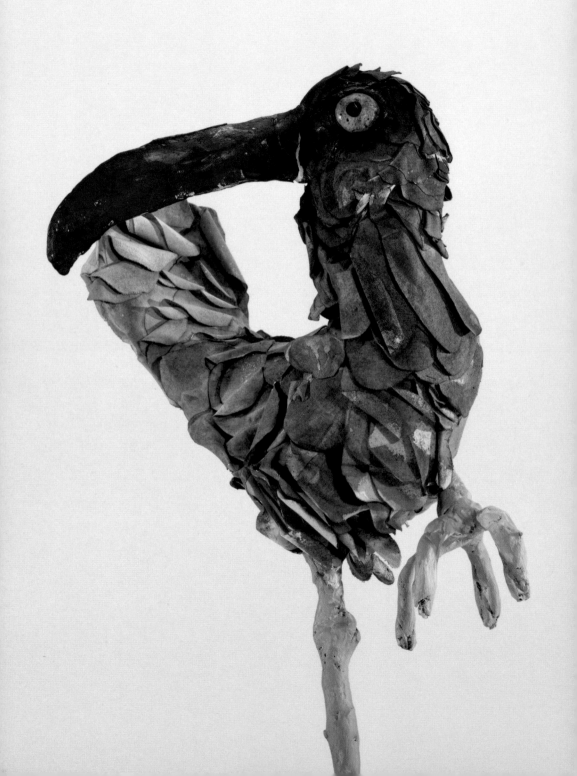

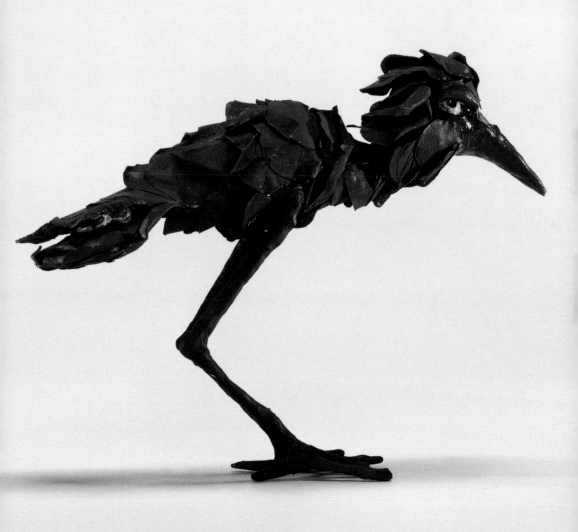

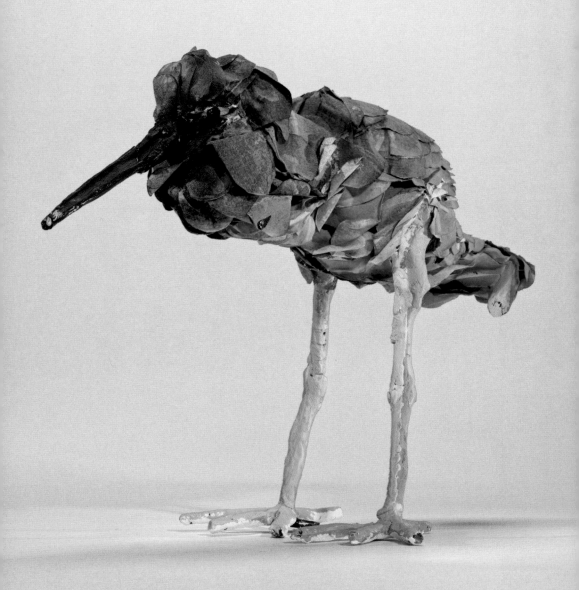

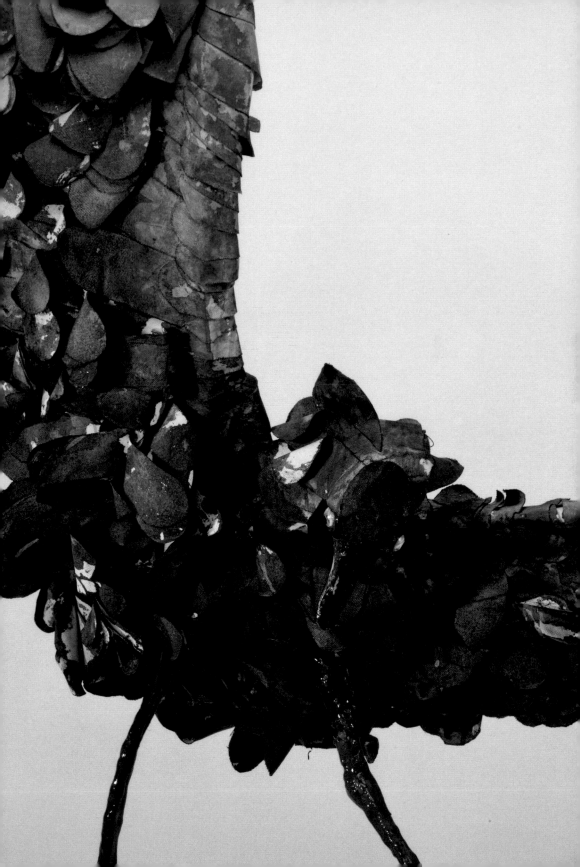

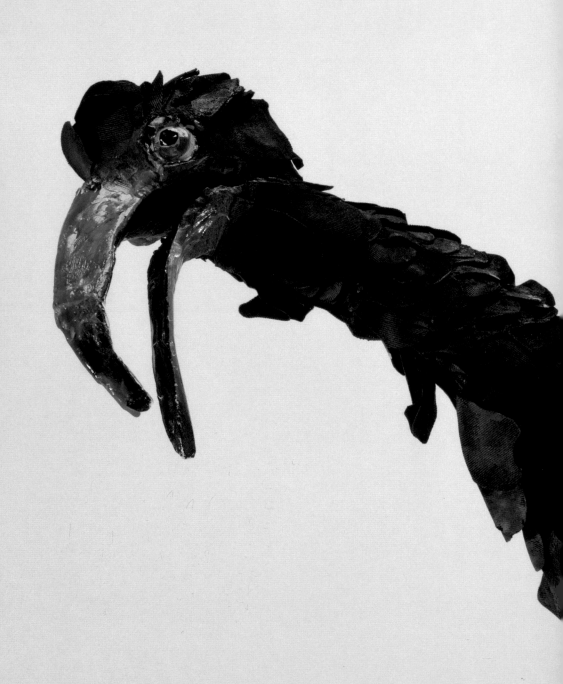

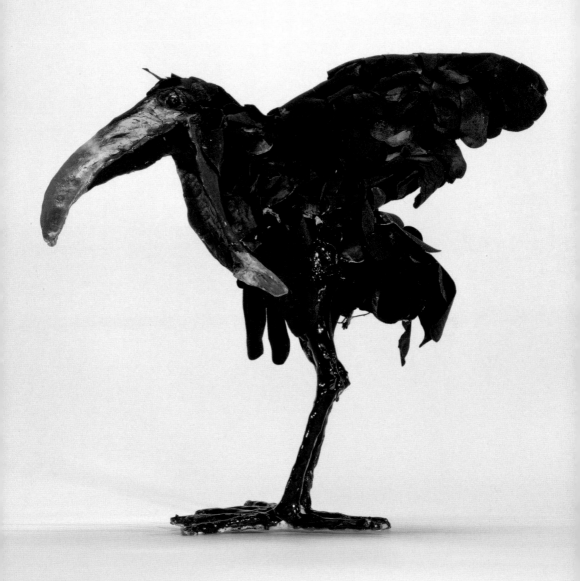

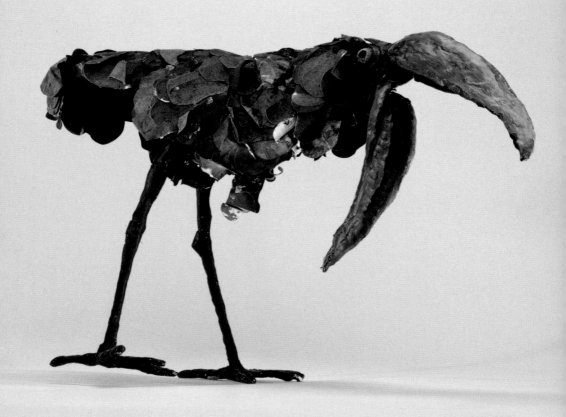

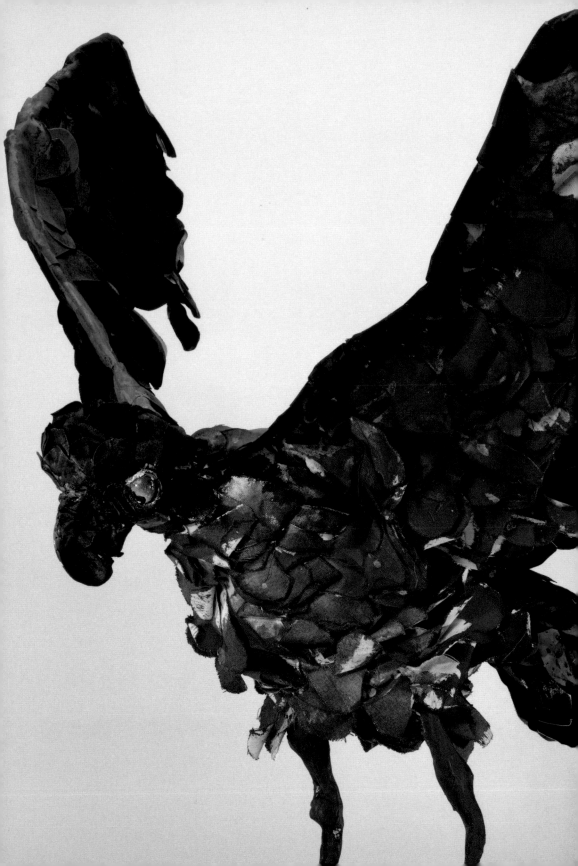

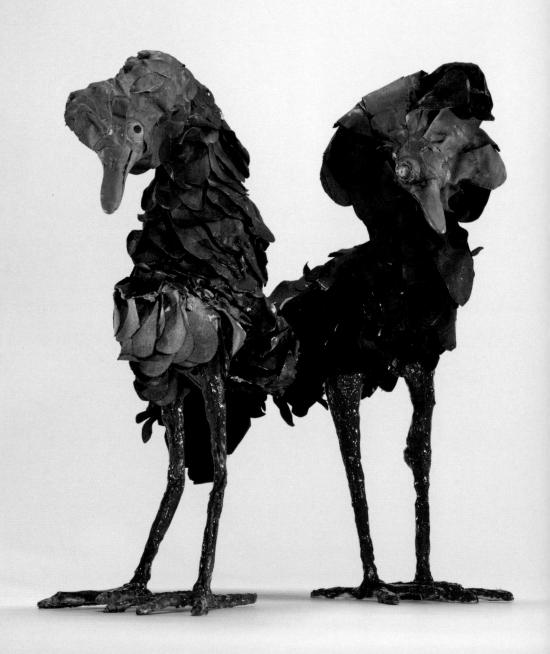

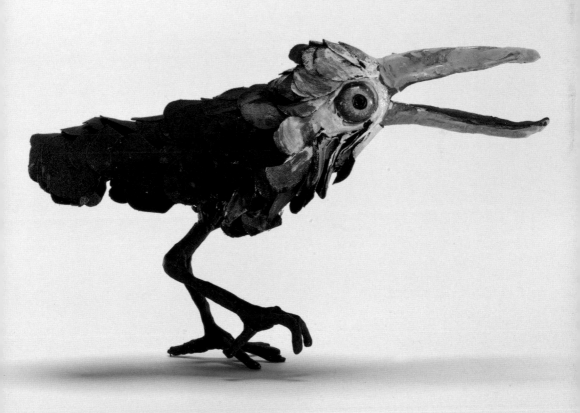

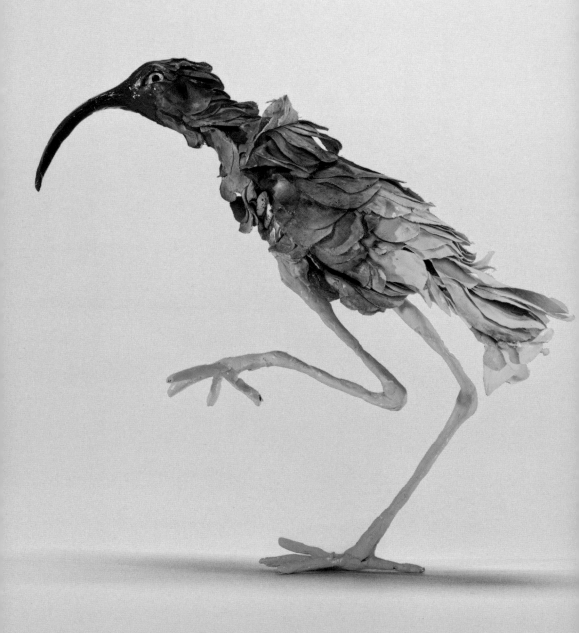

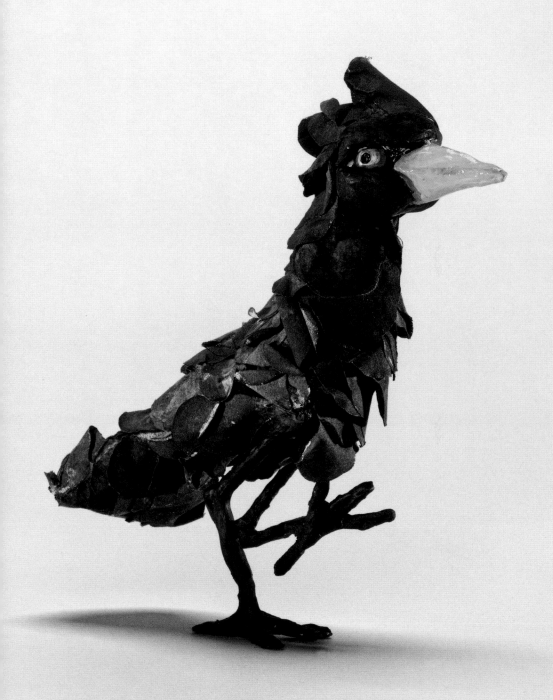

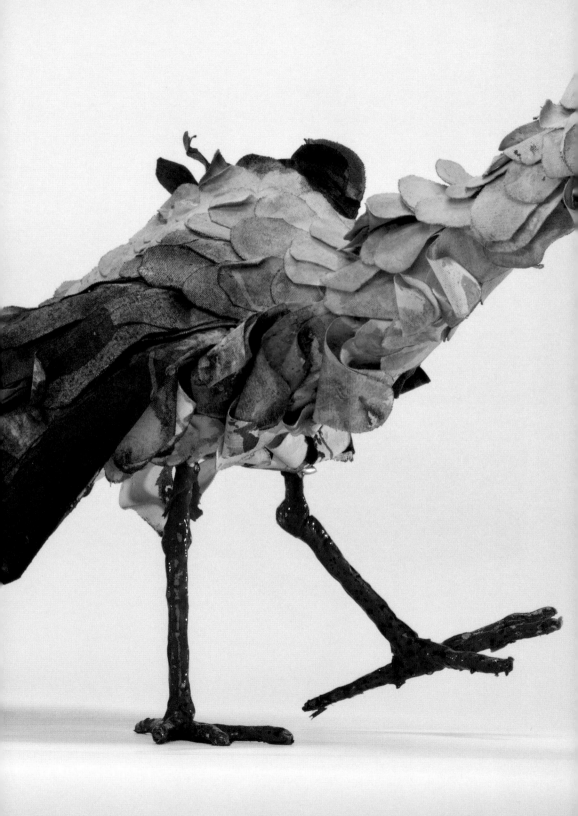

DECEIVING LOOKS

A naked woman exiled on a stretch of desert peers into a hole in the ground. She sticks her hand in to coax out its inhabitant. No sooner is she elbow deep in the cavity than a striped snake wriggles out, baring its sharp fangs and narrowly missing her breast. Tempting the animal with her body, she reaches in again and clutches the tail of the subterranean reptile. Suddenly, another one leaps from a hole into the air and bites off the snake's tail.

Blood spurts forth, unleashing a series of incredible transformations. After the snake's wound is staunched with a furry mask, the two-faced animal slithers around, trying to win the woman's favor. She looks on, stunned and horrified, as other serpents emerge from the ground. Various hues of blood, ranging from dark green to fuchsia, cover the earth as the creatures tear each other apart. Where their bodies are severed, new guises appear—those of dolls and birds, mammals and men.

A red-faced handsome devil slowly seduces the woman. He draws close and flashes his piercing eyes to distract her. The others quickly grab her limbs and hold her down. Two snakes attack her vulnerable body, but she deftly dodges their advances. The bloody battle comes to an end when the two serpents bite each others' heads off. The wounded now briefly cuddle with their former prey. At this moment, tenderness triumphs.

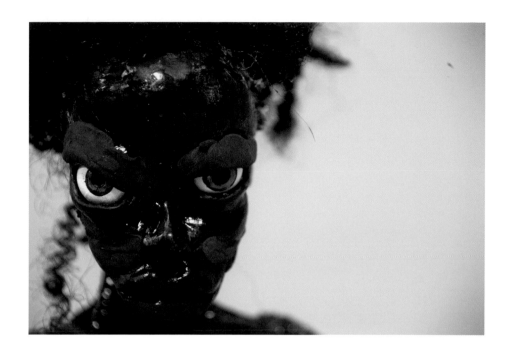

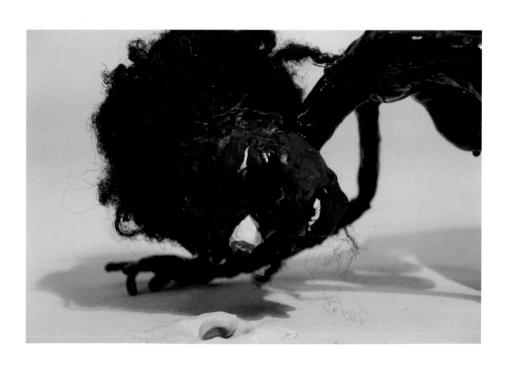

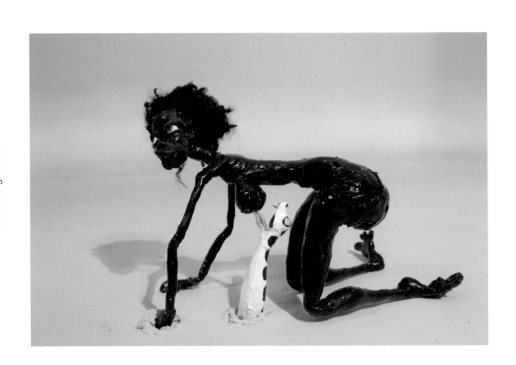

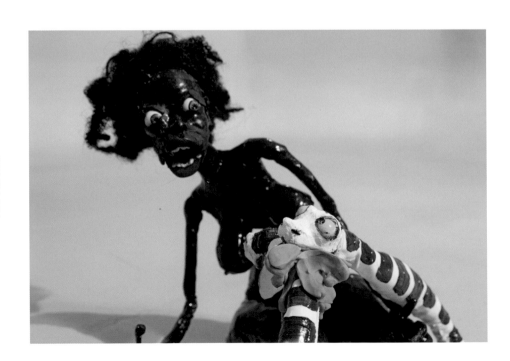

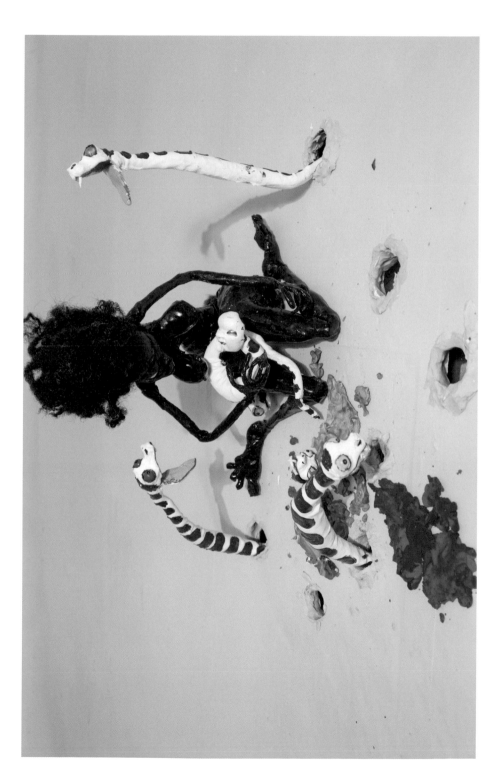

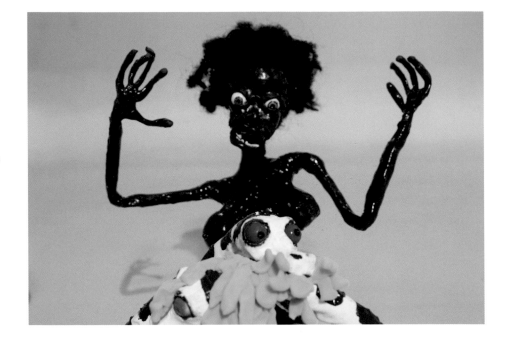

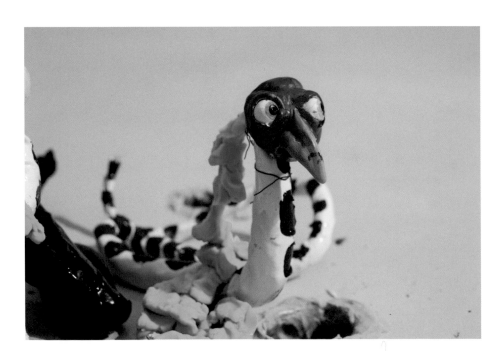

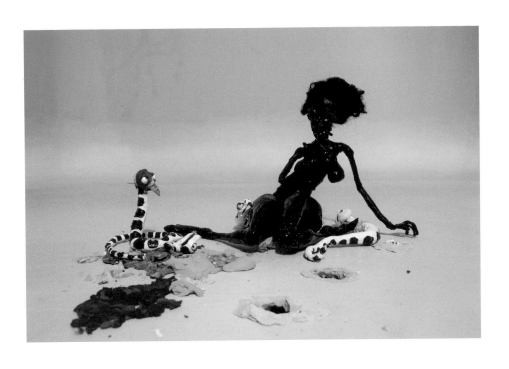

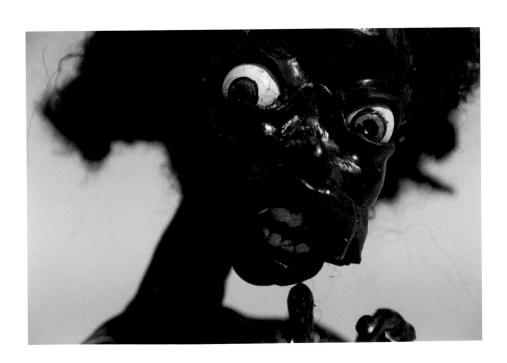

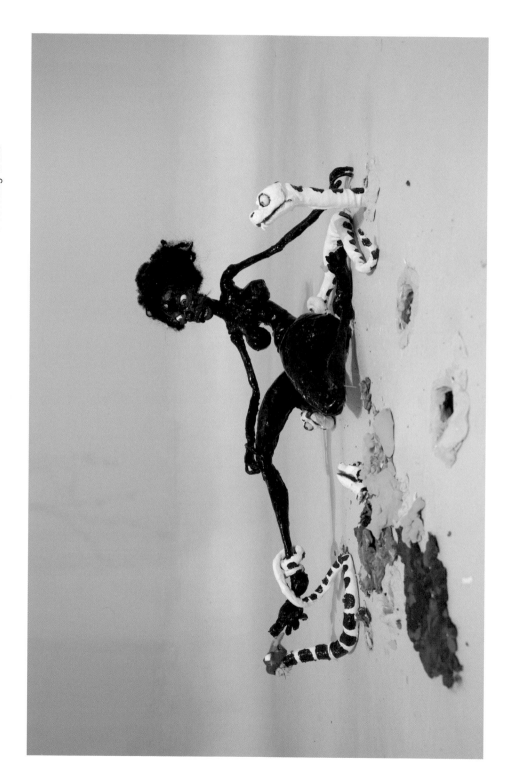

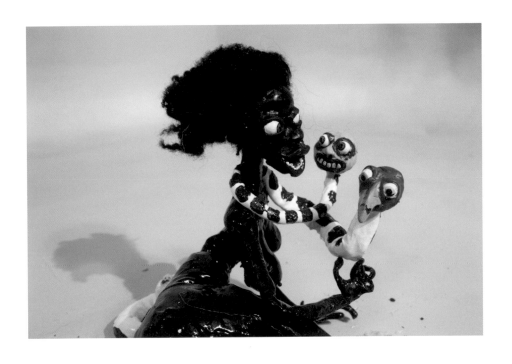

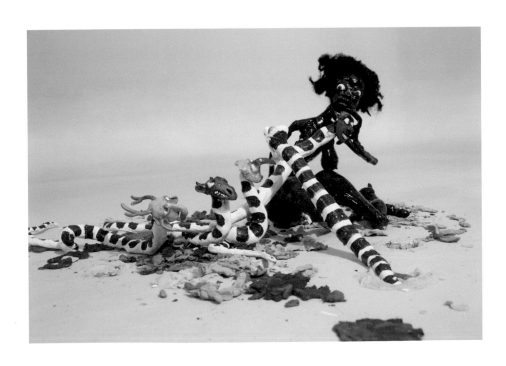

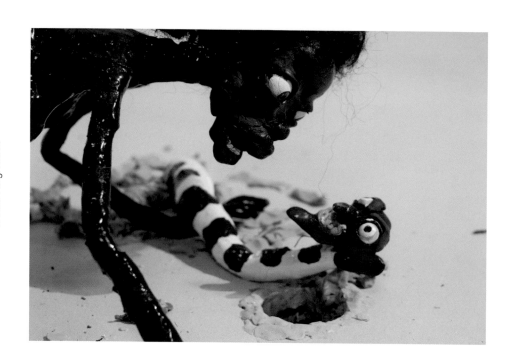

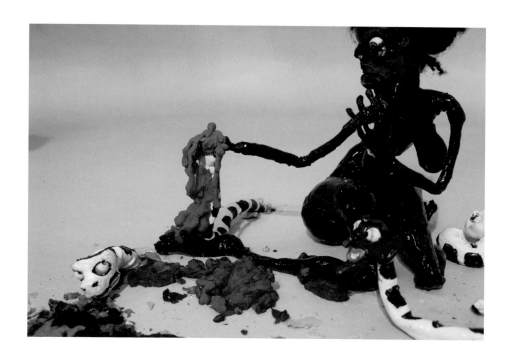

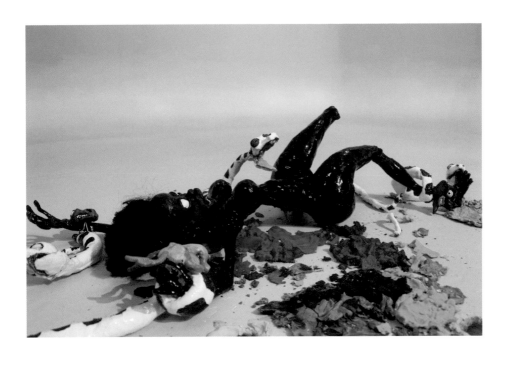

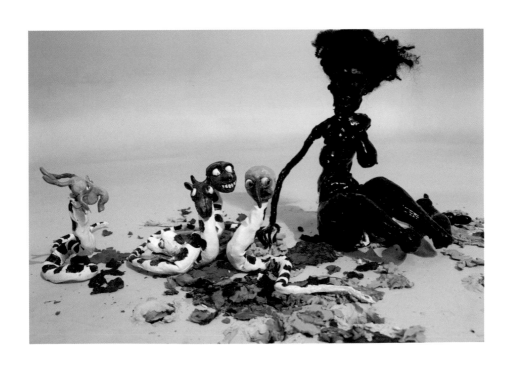

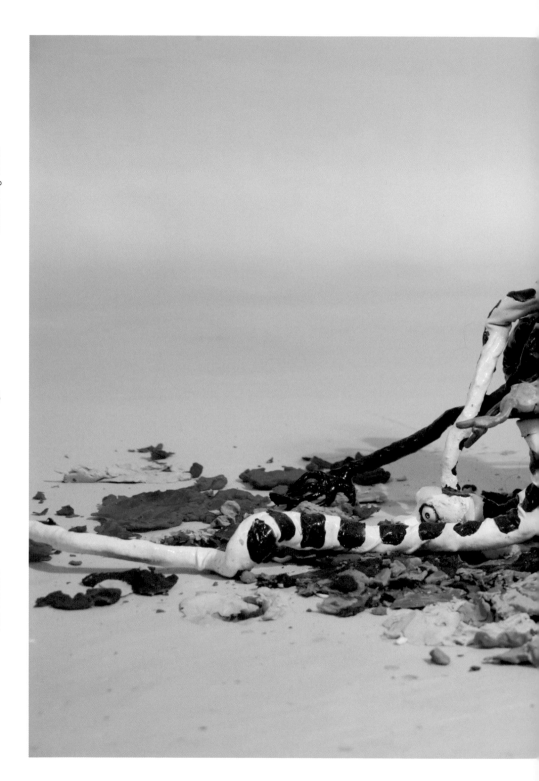

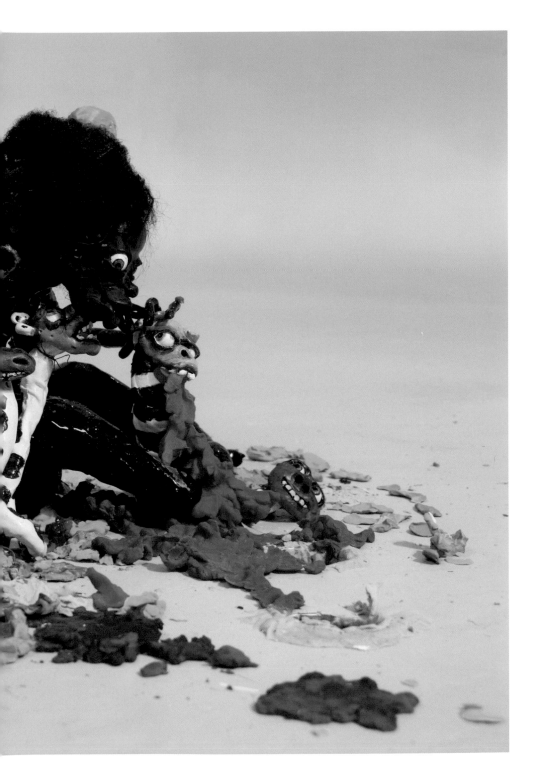

Deceiving looks

I WASNT MADE TO PLAY THE SON

The naked figure of a purple-skinned woman lies prone on the floor as two bird-masked men in breeches step across her. She squirms with apprehension as a steady beat plays. Her initial fear turns to anger as she recognizes the man standing on her chest. Their dialogue appears scrawled on the wall. She says, "I treated you like a son," as she caresses his leg. He squats down and brushes her forehead sympathetically. "I wasn't made to play the son," he replies.

The man in royal blue makes the first cut. With a sharp click of his scissors, he removes one of her toes and green blood pours from the wound. An ominous tone follows each assault. "It will be over in no time—one second," he says, after snipping off another. His partner strokes the woman's face, but his attempts to soothe her fail. They shear off her fingers and pink gore oozes forth. "Close your eyes." They savagely fillet her breast. "Relax," one says. More toes and a kneecap. "It won't hurt none," the other promises, as he severs a hand. Orange blood erupts.

50

Walking on tiptoe across her body, they carefully consider their next incisions. "There, there." One removes her leg at the knee and then brutally yanks a tooth from her mouth. Suffocating on spumes of green blood, she frantically begs for mercy. "Breathe easy." The other cleans her face and pats her cheek. "Easy now." An arm, another leg, more teeth—they cast her parts aside, as the woman is consumed by her own body's fluids. "Easy."

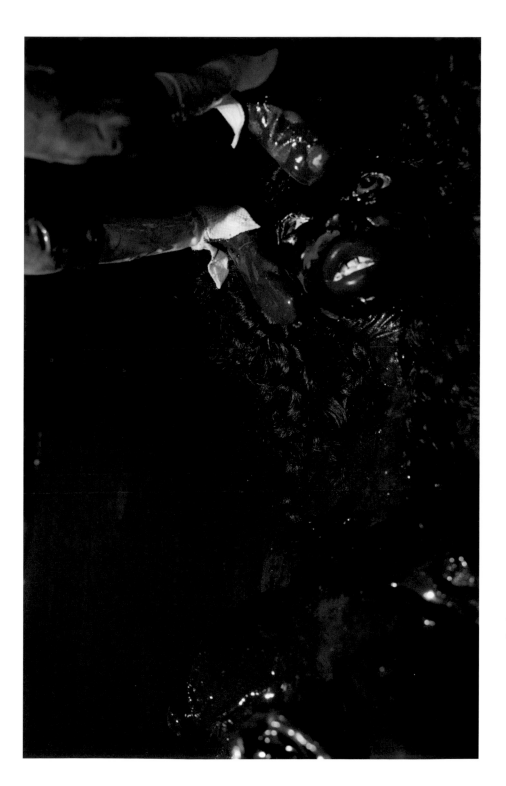

I wasn't made to play the son

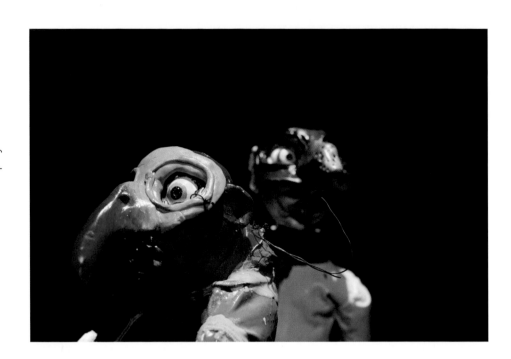

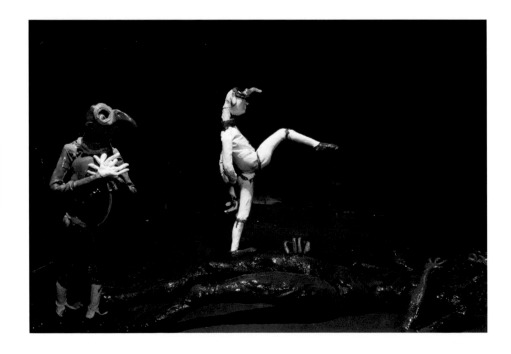

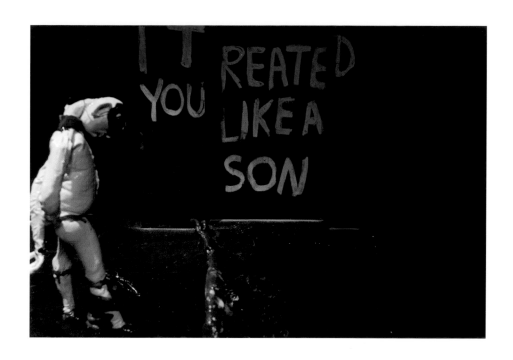

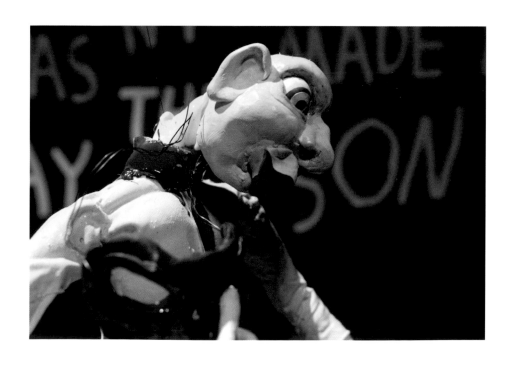

I wasn't made to play the son

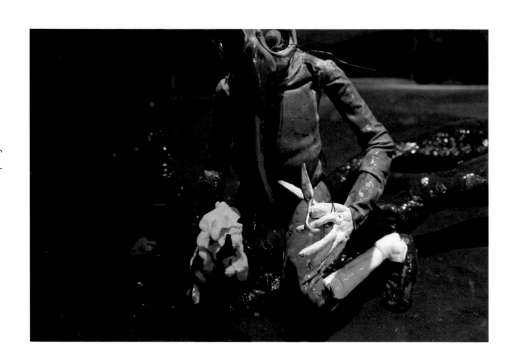

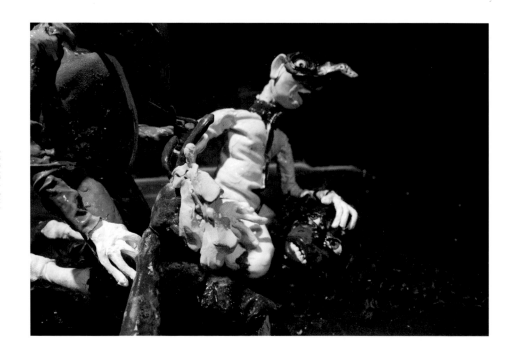

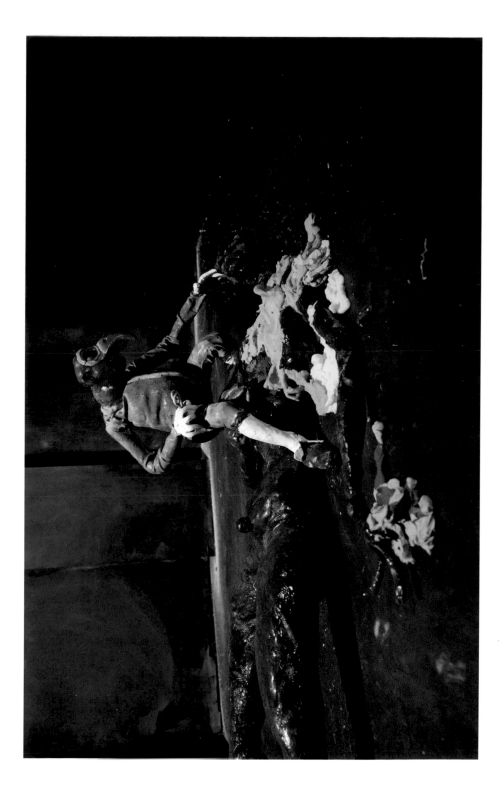

I wasn't made to play the son

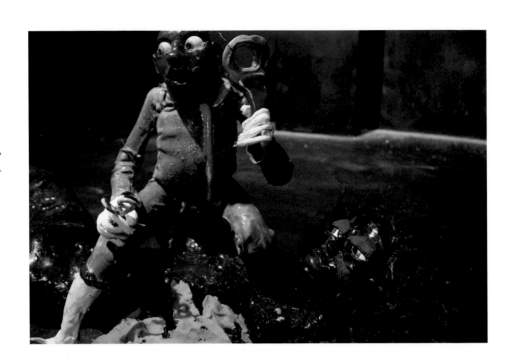

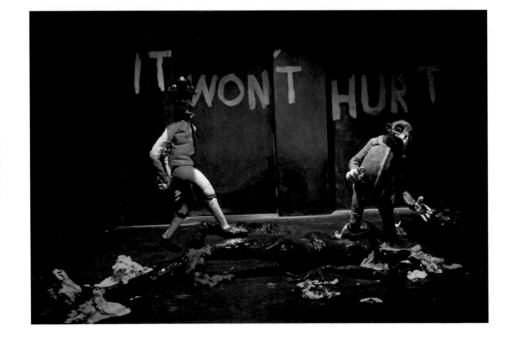

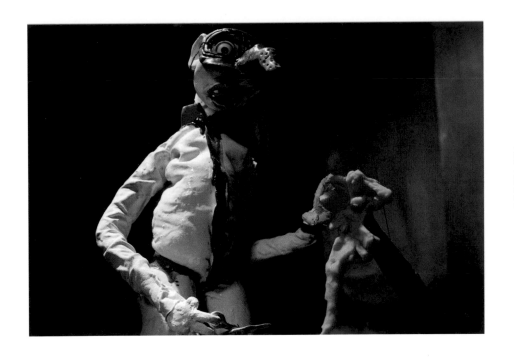

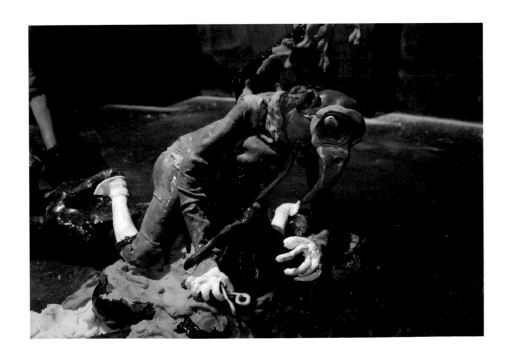

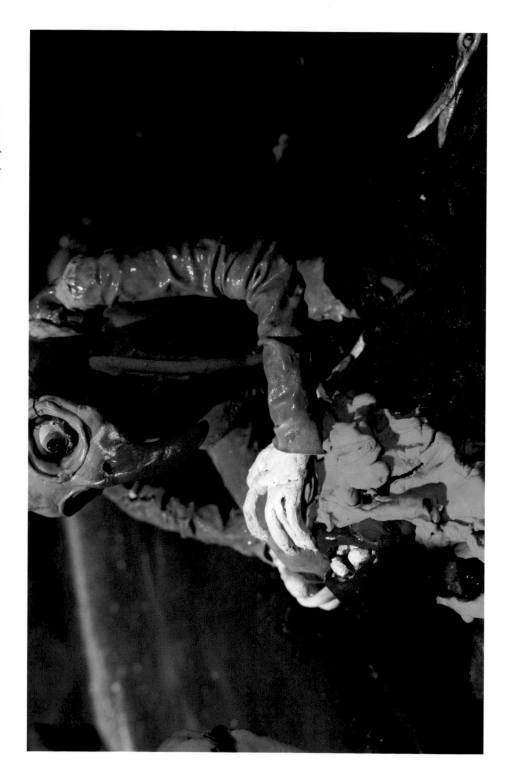

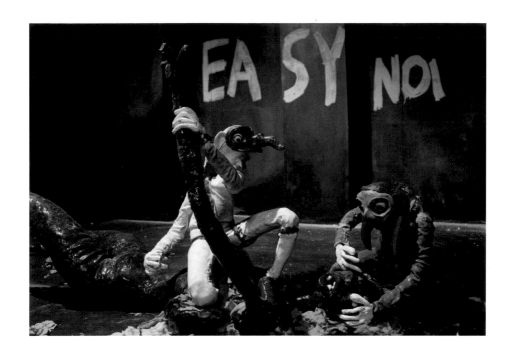

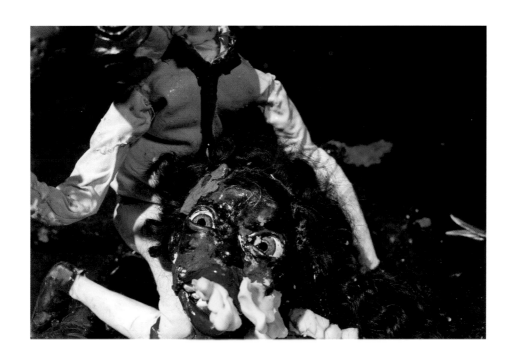

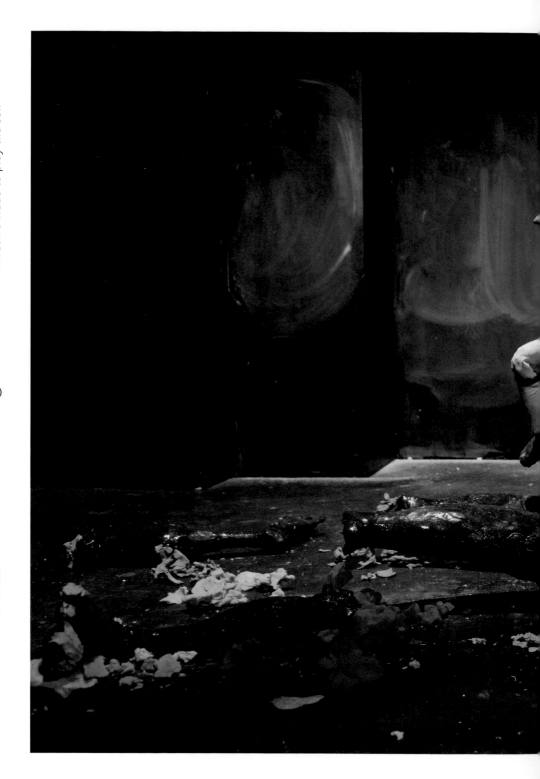

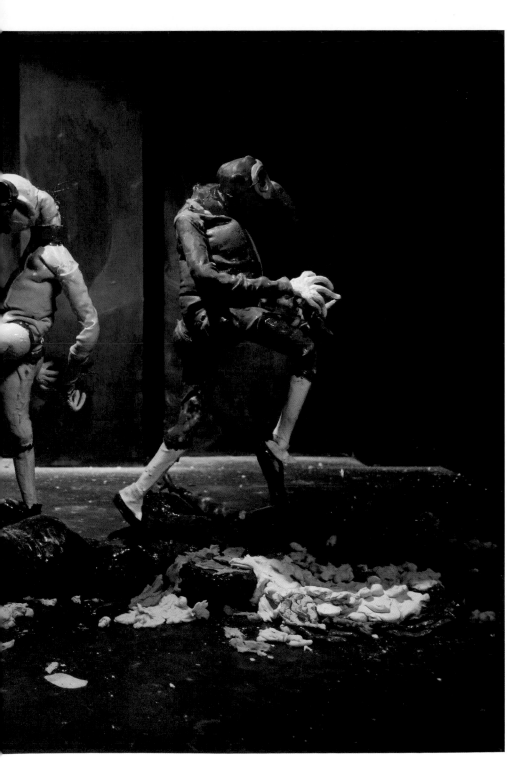

I wasn't made to play the son

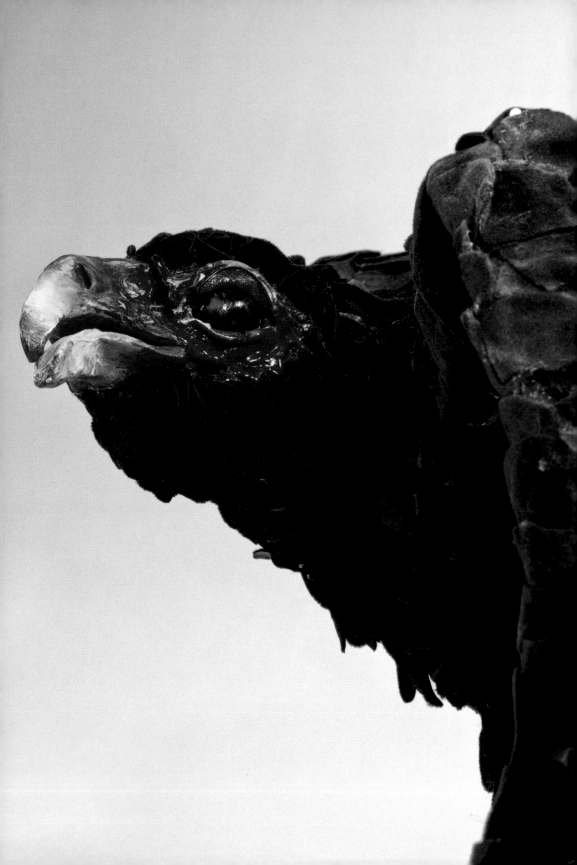

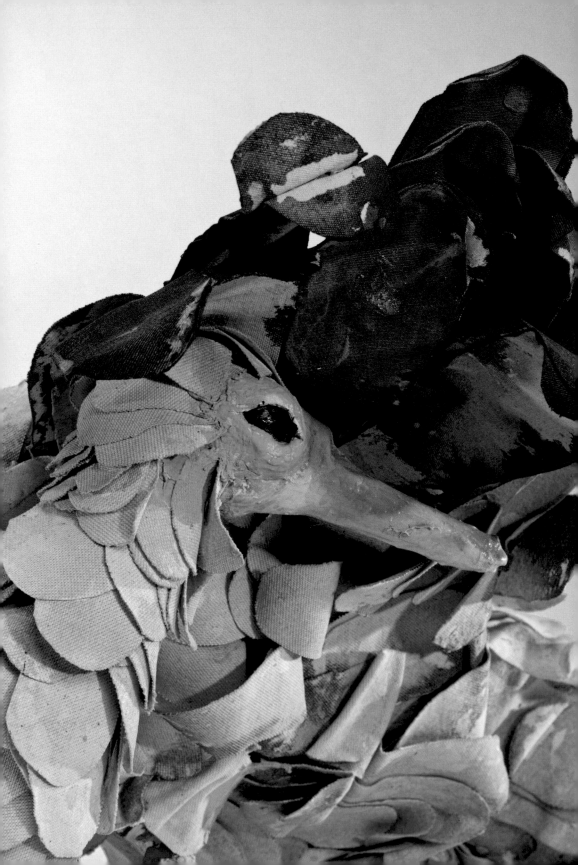

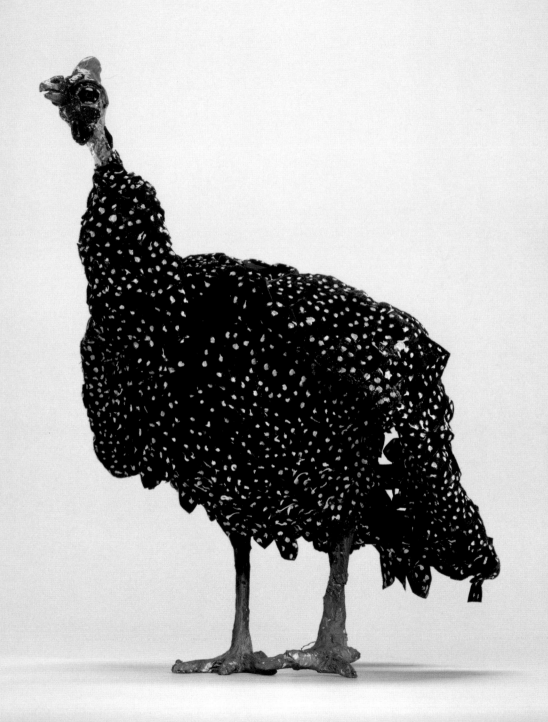

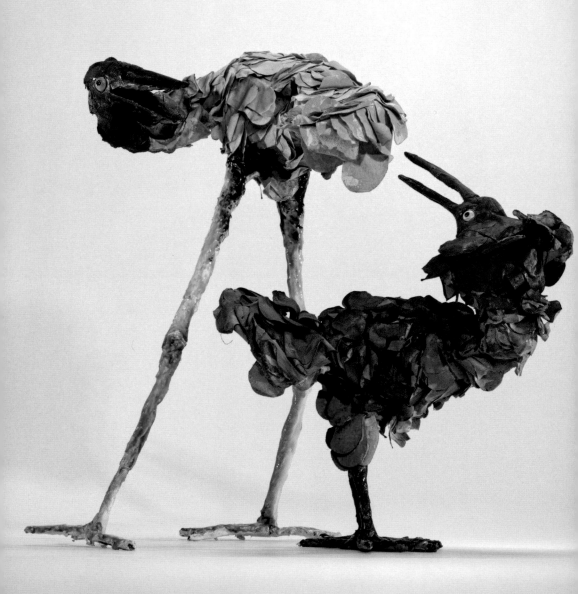

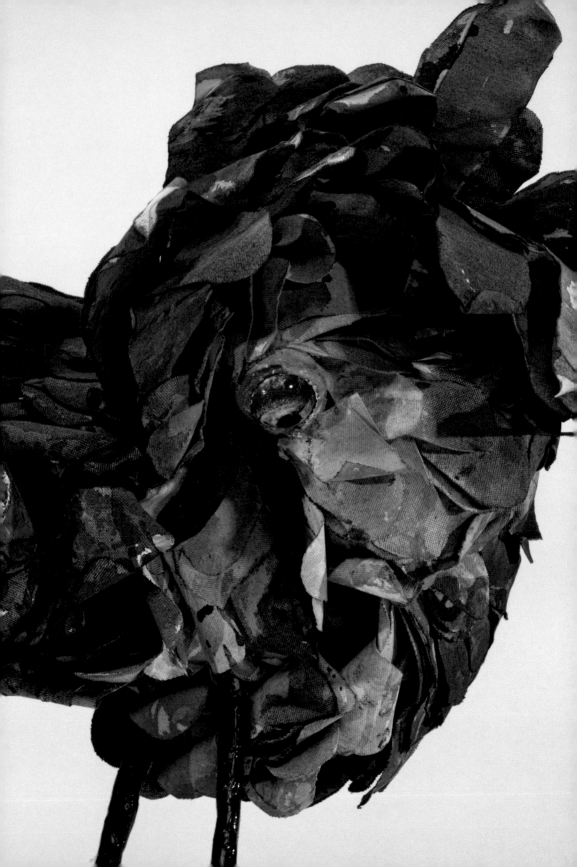

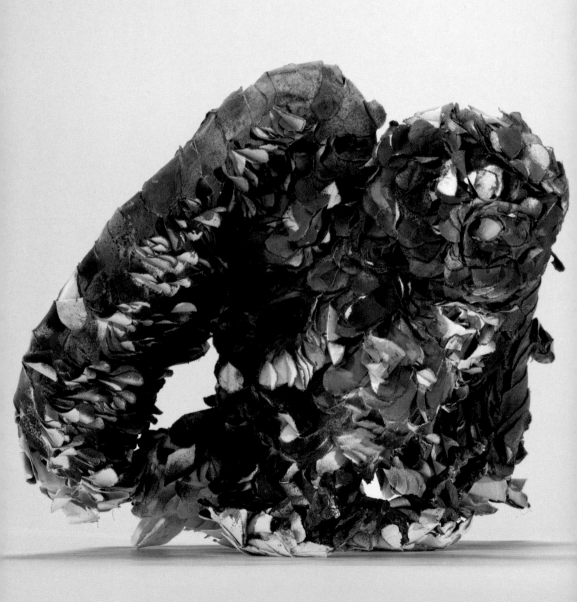

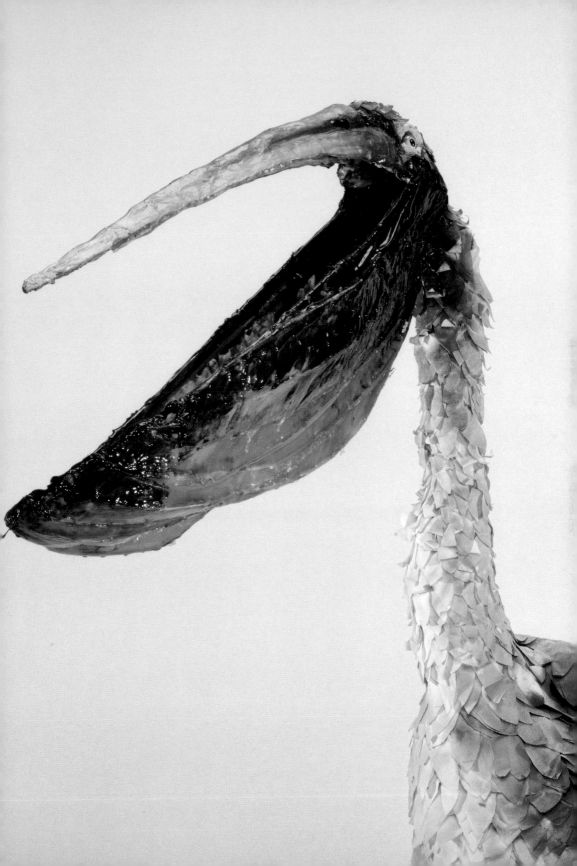

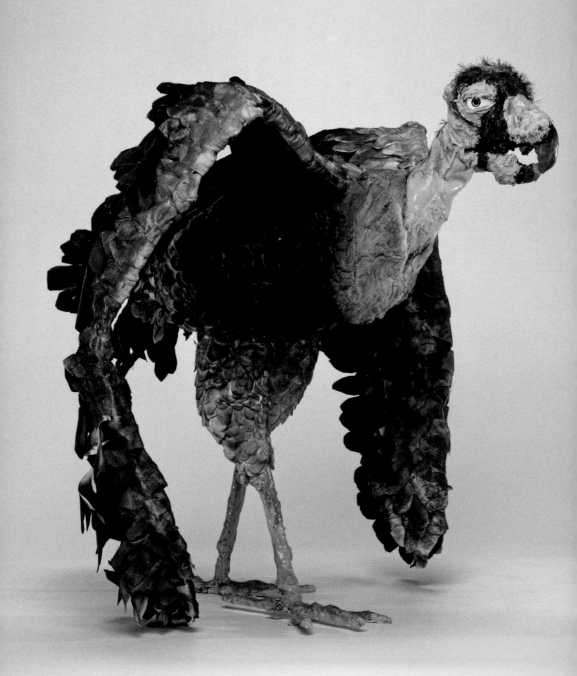

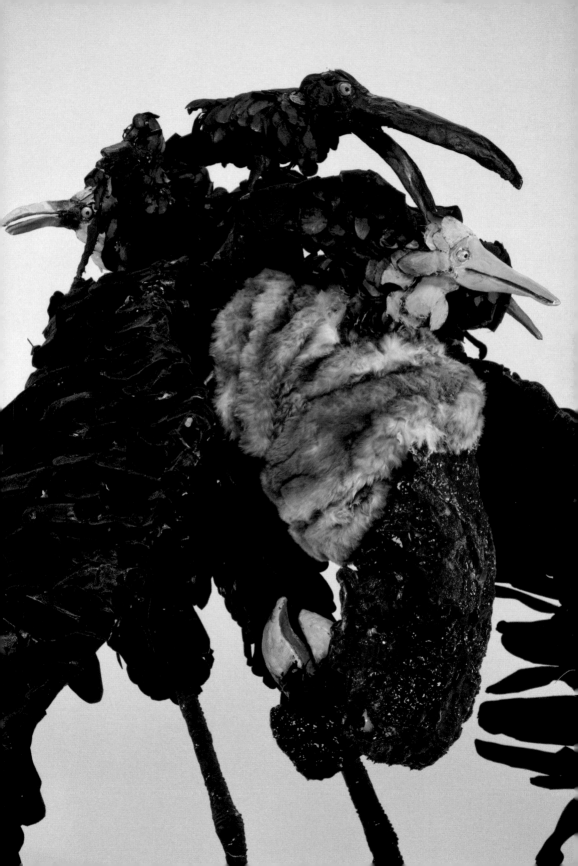

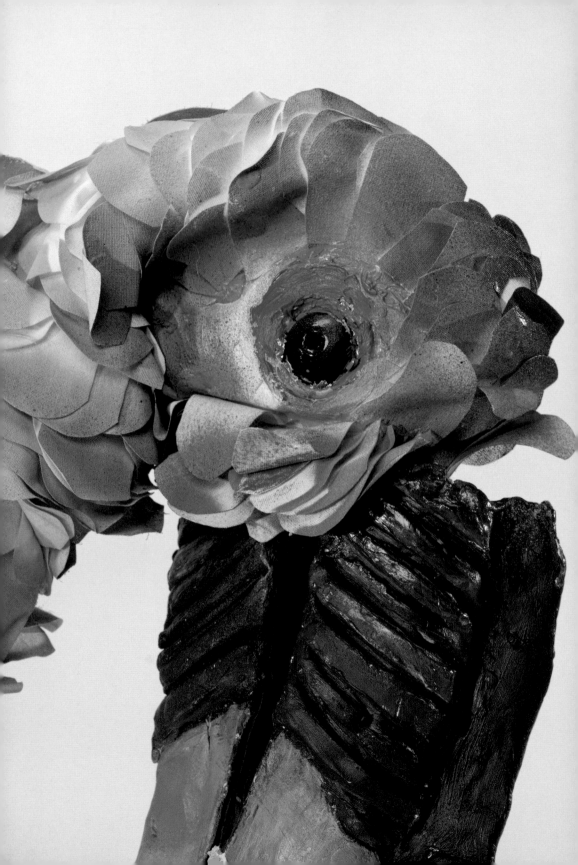

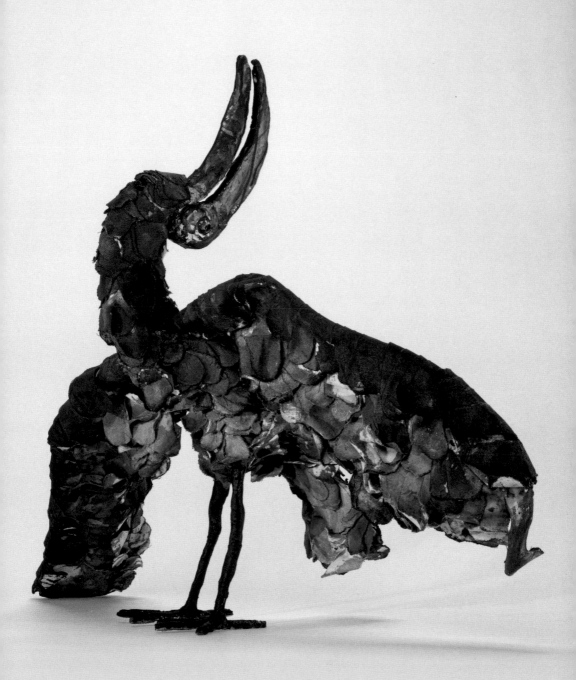

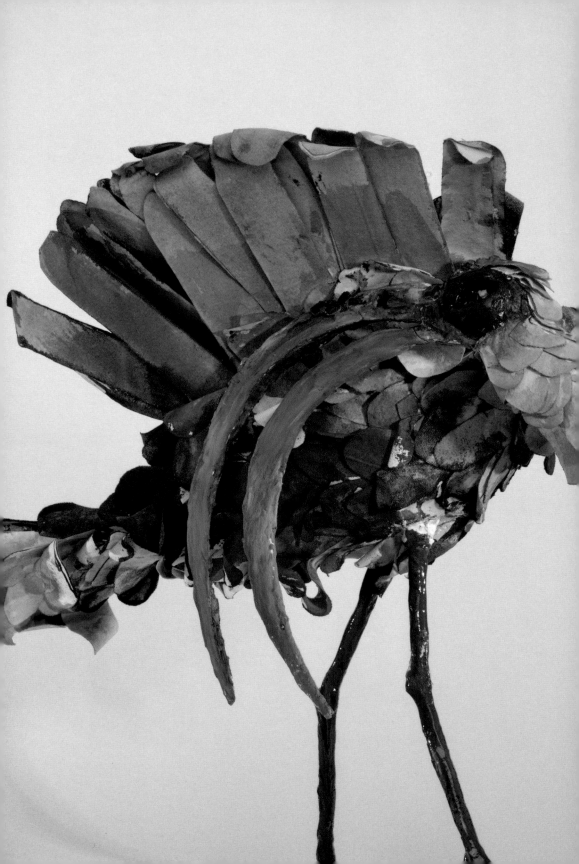

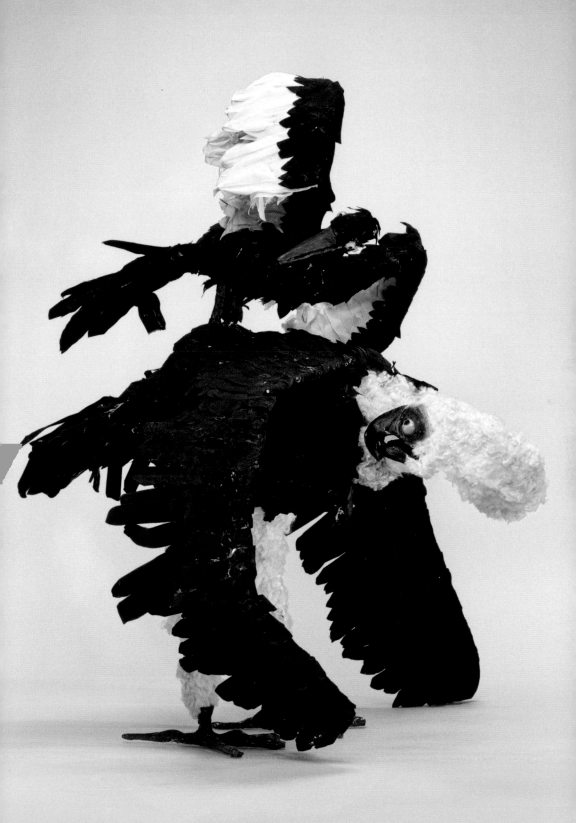

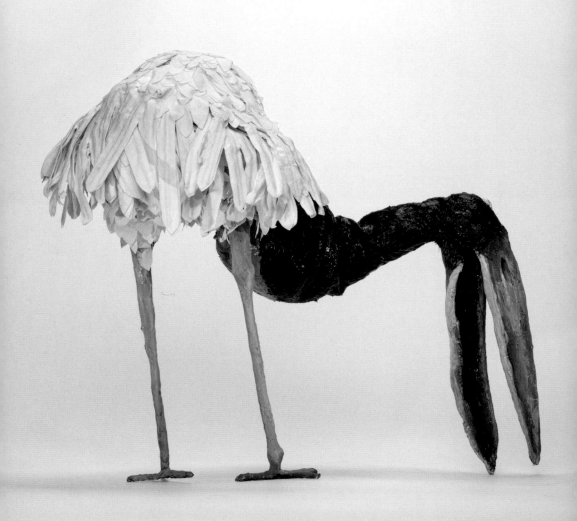

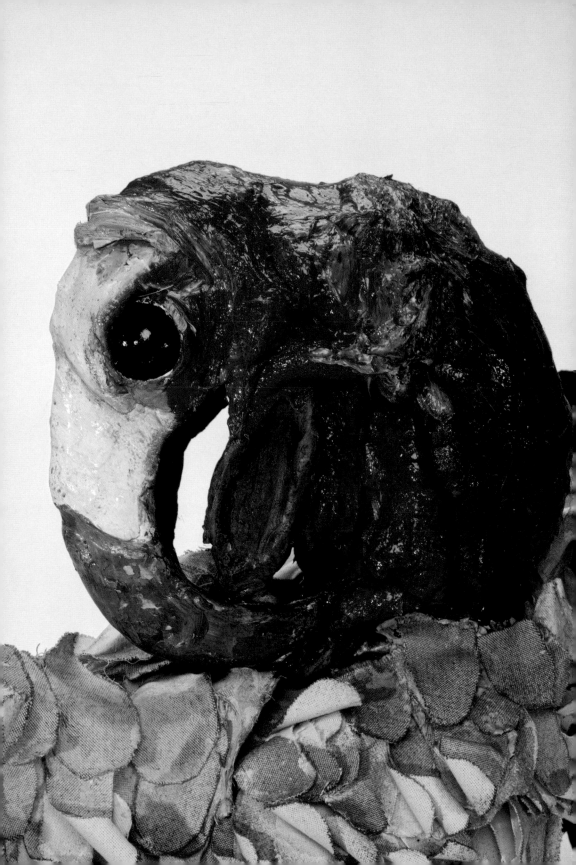

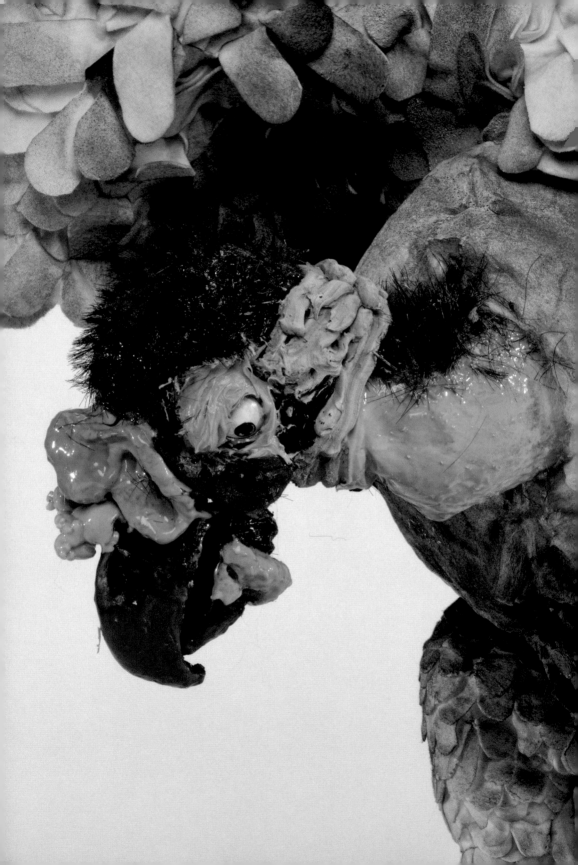

I AM SAVING THIS FOR LETTER

Unlikely cohorts, a caped gentleman and a snaggle-toothed crocodile traverse a barren hillside. The man sniffs something buried deep within, and the reptile circles with anticipation, snapping its jaws. When they agree on a spot, the man pulls a spade from his cloak and begins to dig.

Momentarily distracted from the task at hand, the man puts on a green mask and looks to the crocodile, who responds with a grinning mask of his own. A strange play of expressions ensues as the man and the reptile display a variety of personas—from benign herbivores such as goats and elephants to menacing humanlike faces. Their mischievous foolery becomes threatening when the man, wearing a wolf mask, swats at his accomplice.

When he resumes his excavation, the man unearths layers of multicolored clay, much to the crocodile's delight. Standing on its hind legs, the smiling reptile claps its paws in amusement and then joins in the chore. The two discover a giant white egg below the rainbow sediment. With a sheepish expression, the man cuddles the egg and raps on it, listening to what's inside. He rolls the egg to the surface, and the crocodile snaps at it with his sharp teeth. When the man puts on a crocodile mask, his conspirator retaliates, swatting him into the hole with its tail. Despite the man's desperate pleas for mercy, the reptile buries him alive. Content to be alone with its prize, the crocodile rolls the egg atop the fresh grave and perches on it like a bird.

80

I am saving this egg for later

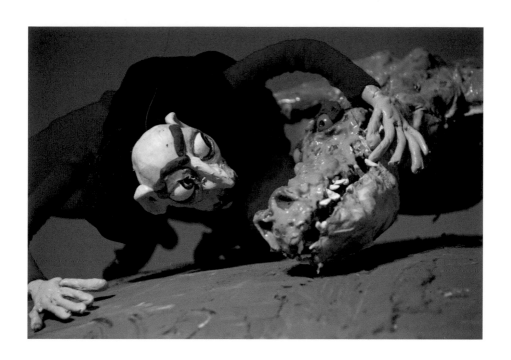

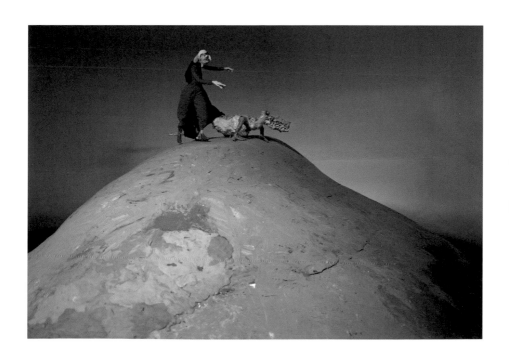

The Parade

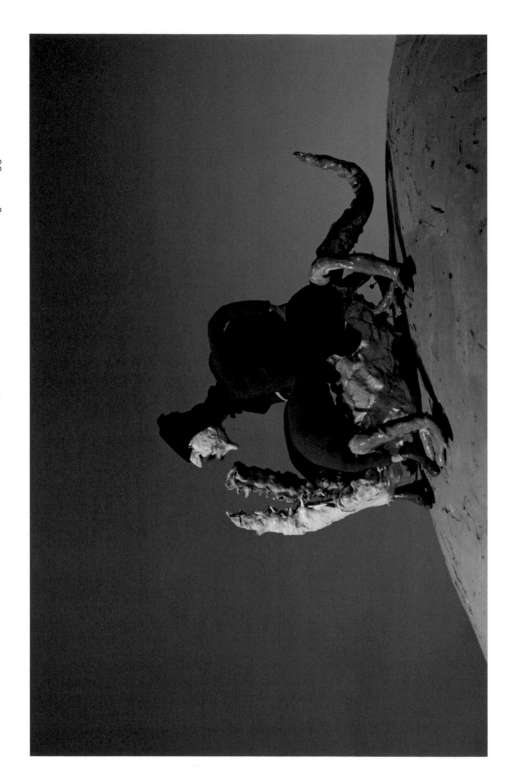

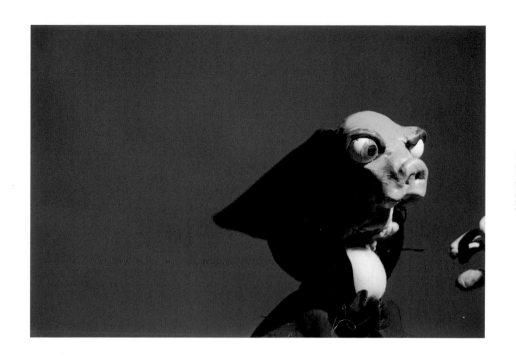

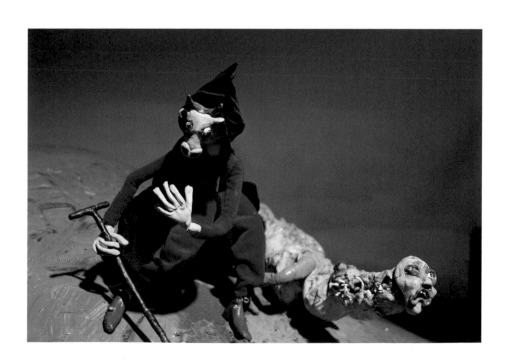

I am saving this egg for later

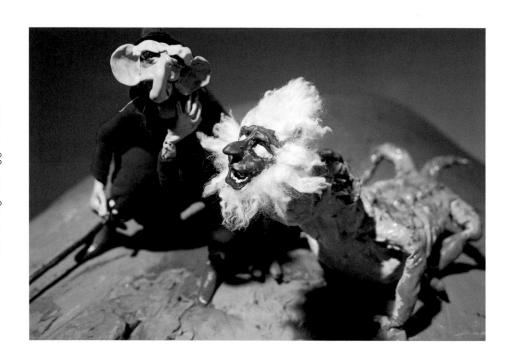

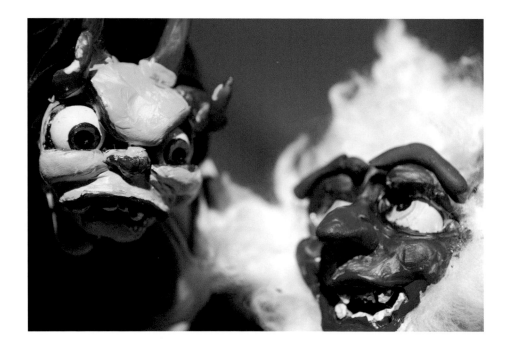

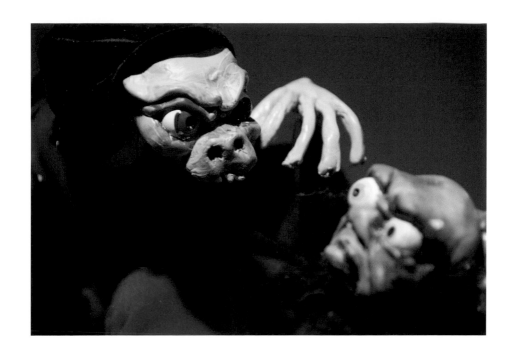

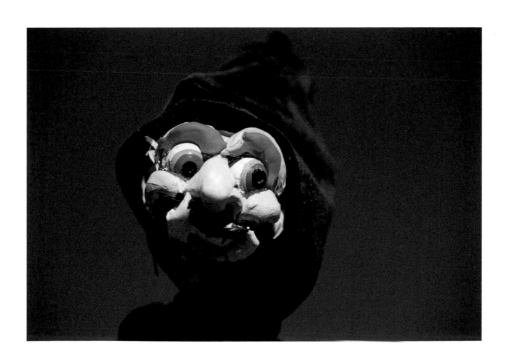

I am saving this egg for later

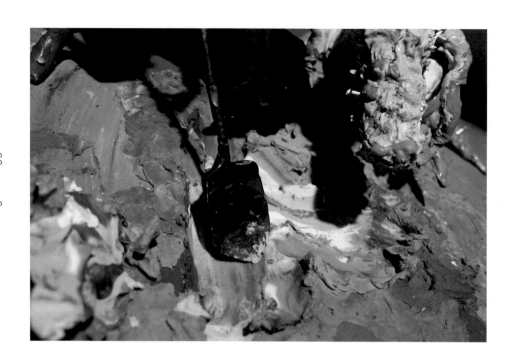

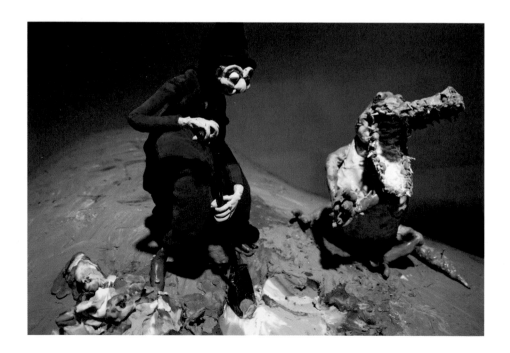

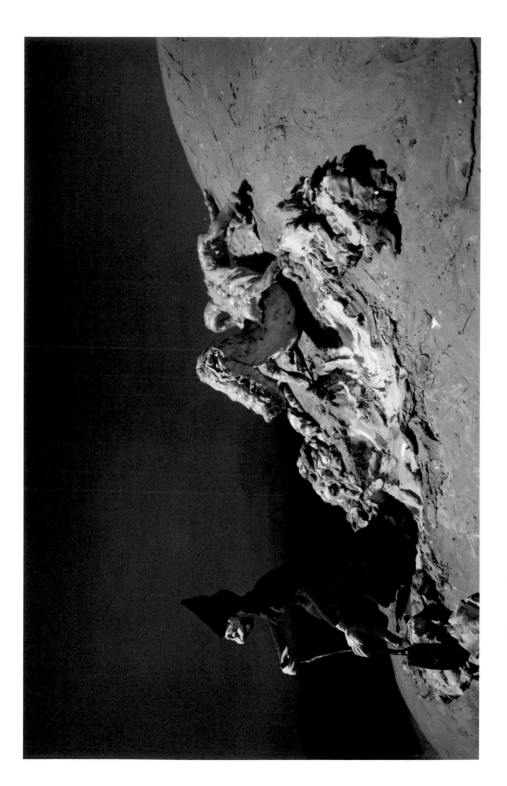

87

I am saving this egg for later

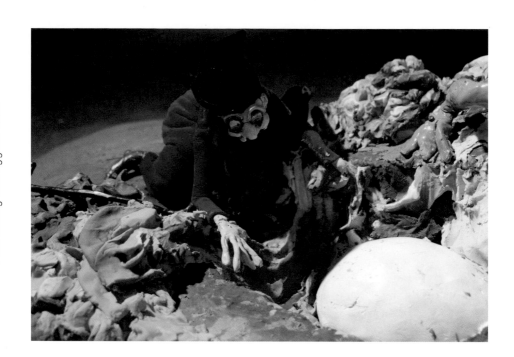

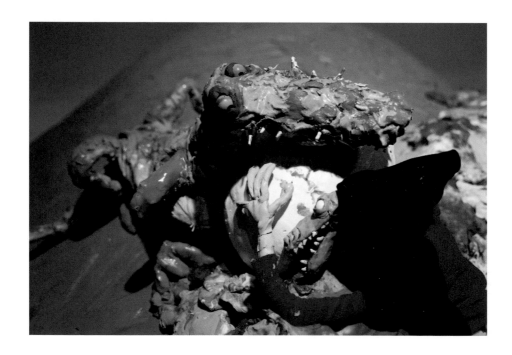

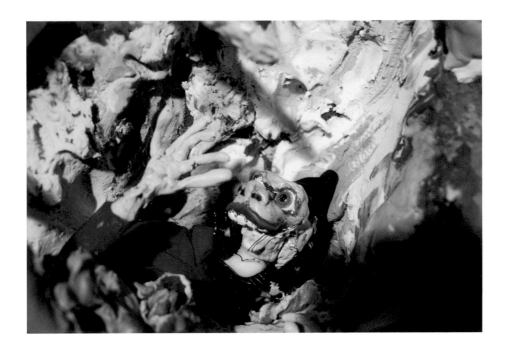

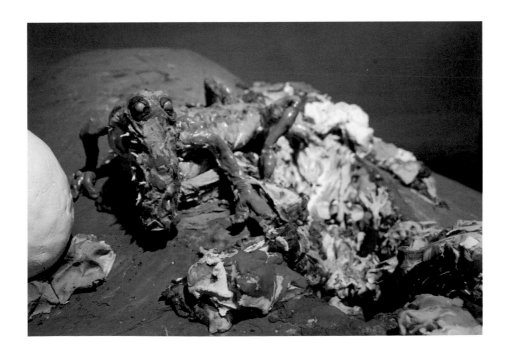

I am saving this egg for later

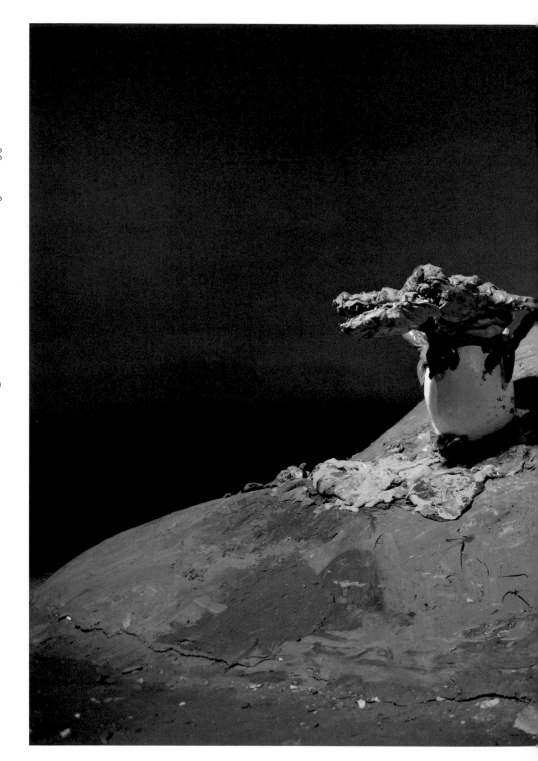

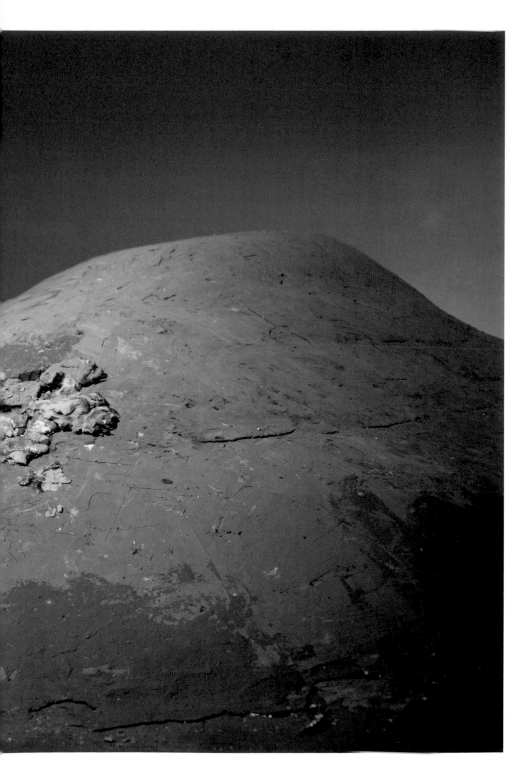

I am saving this egg for later

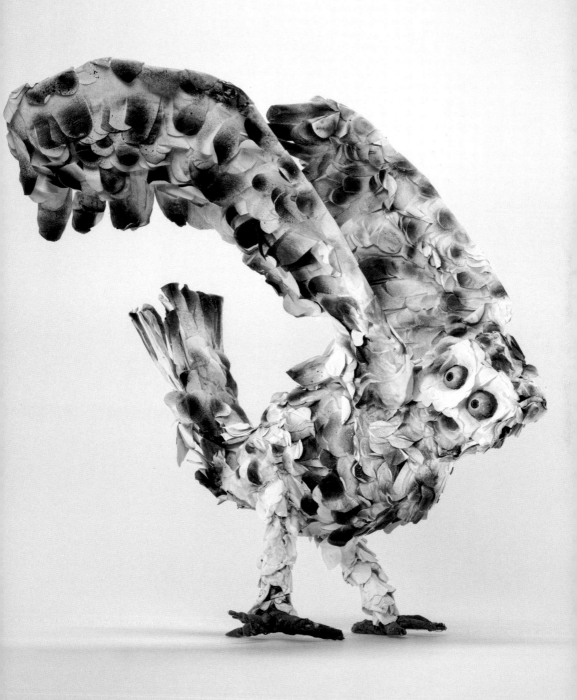

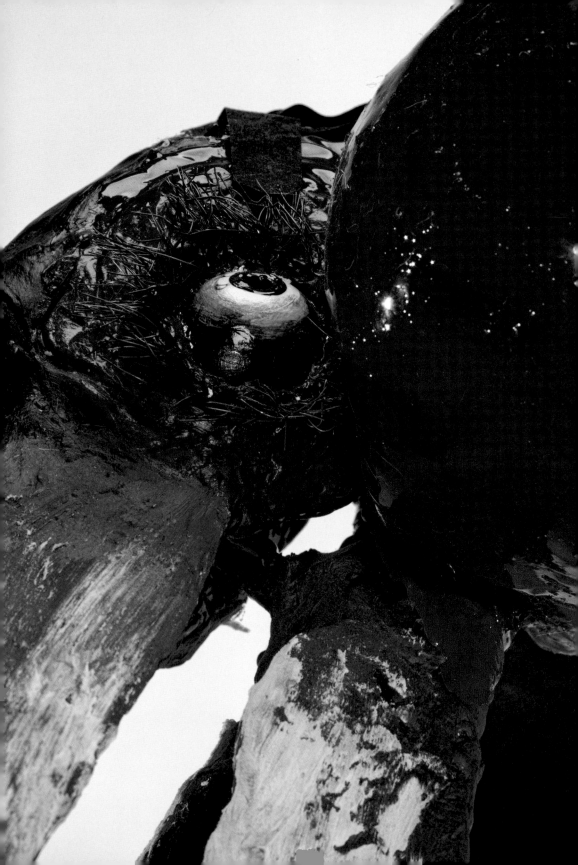

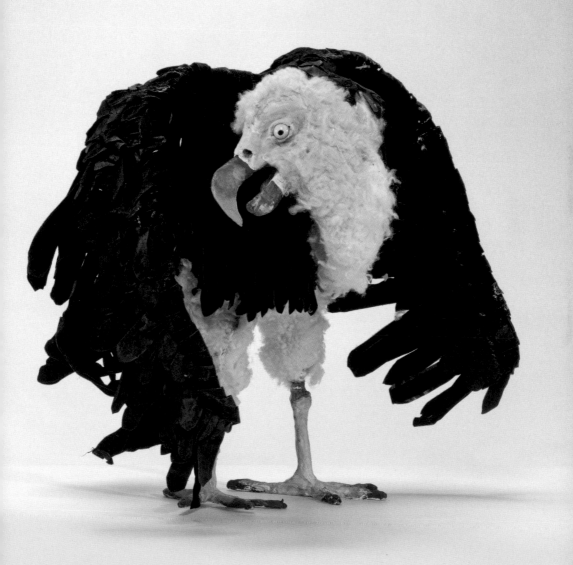

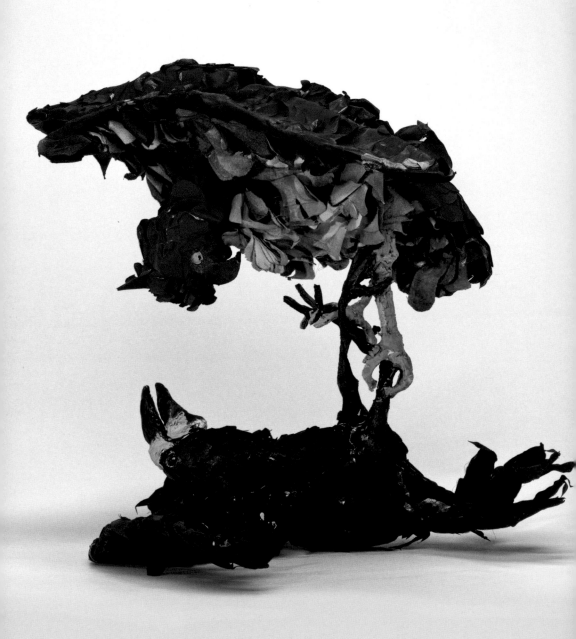

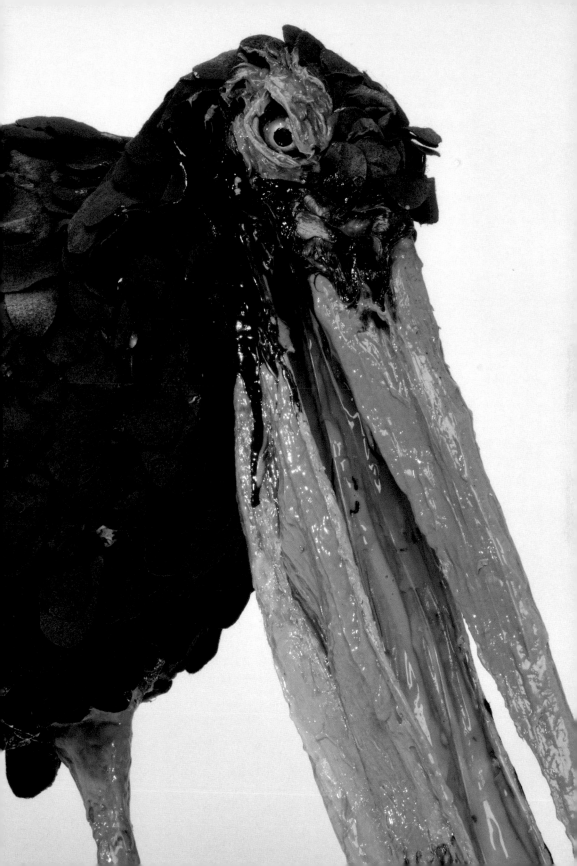

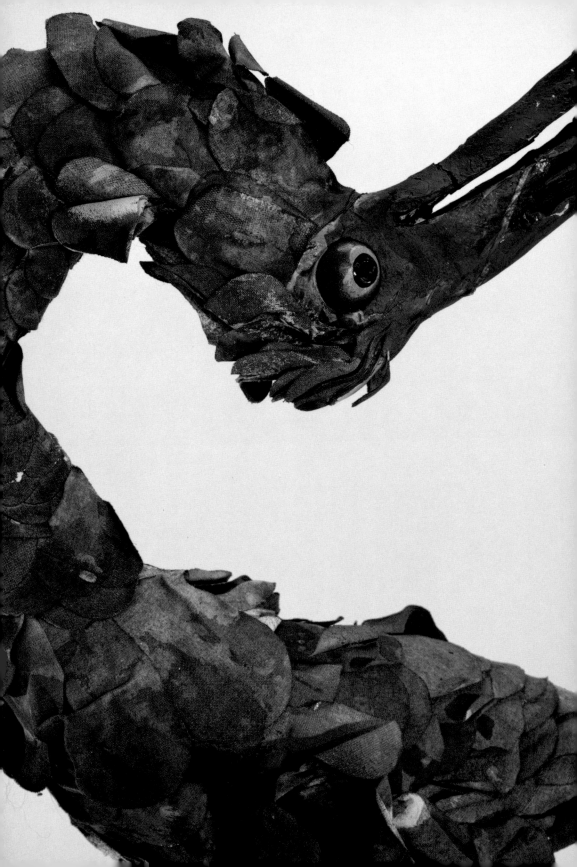

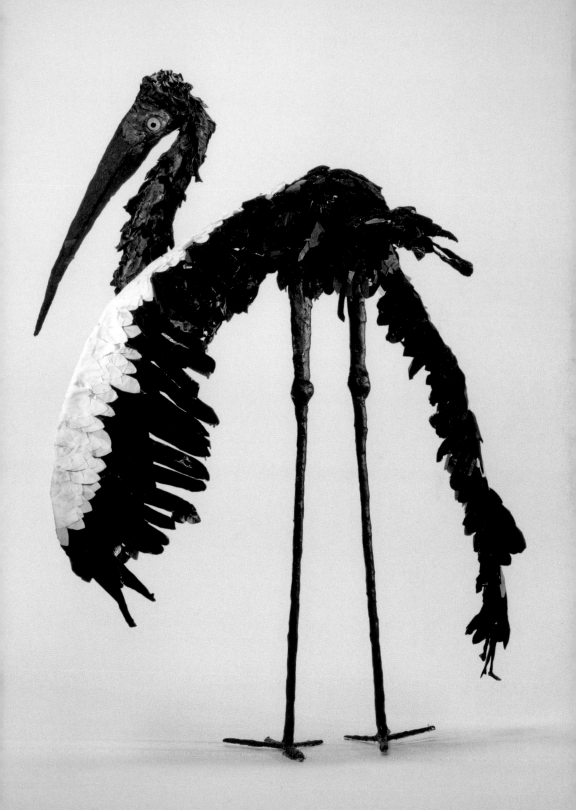

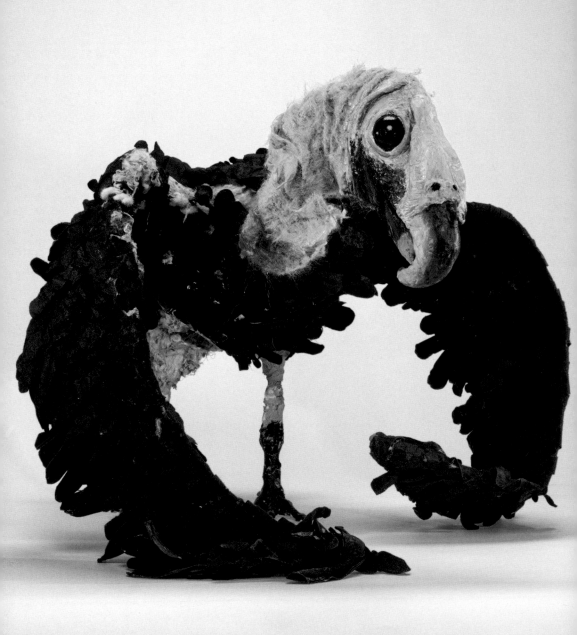

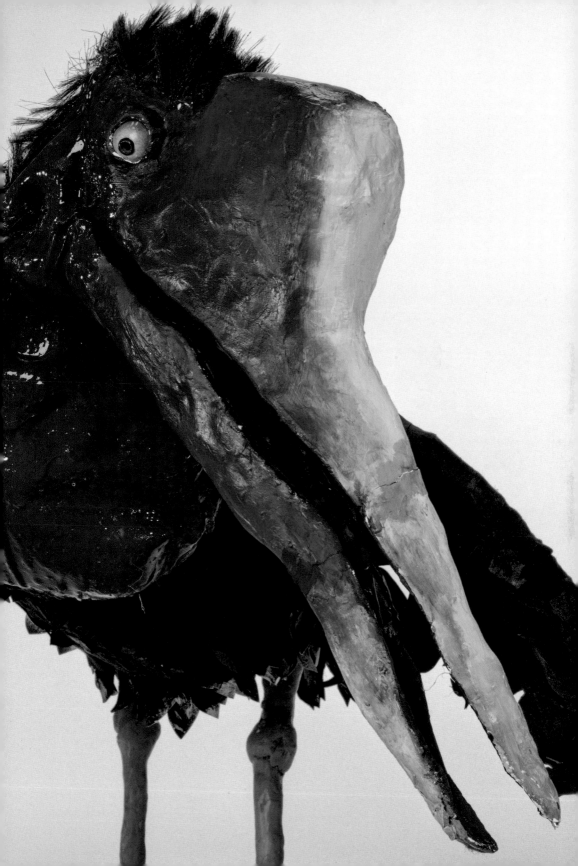

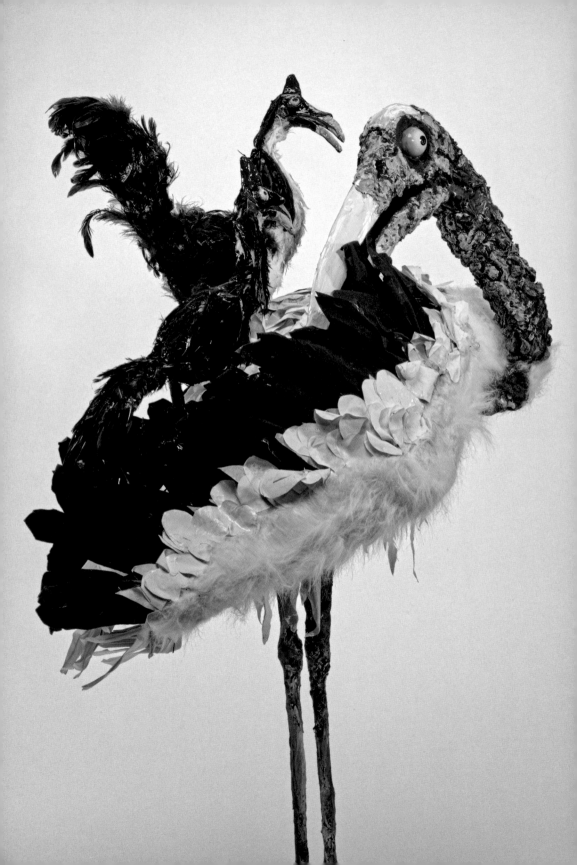

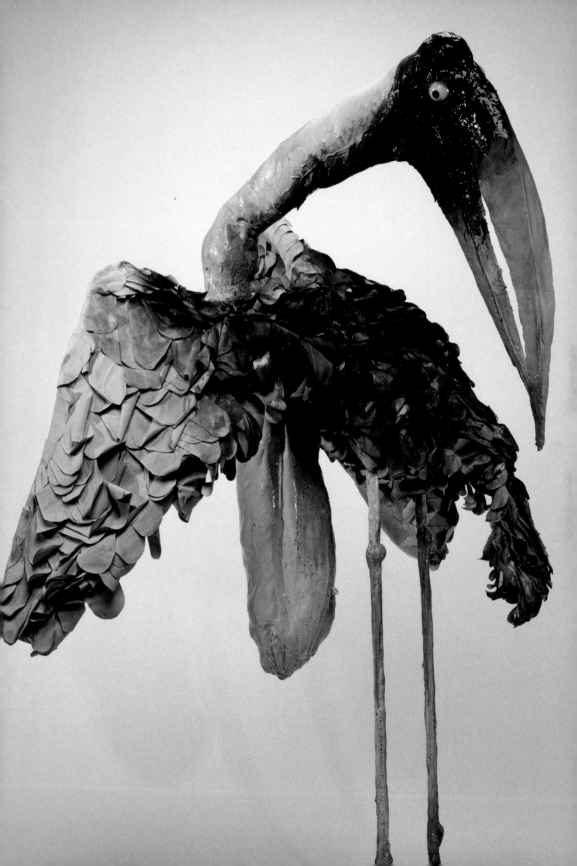

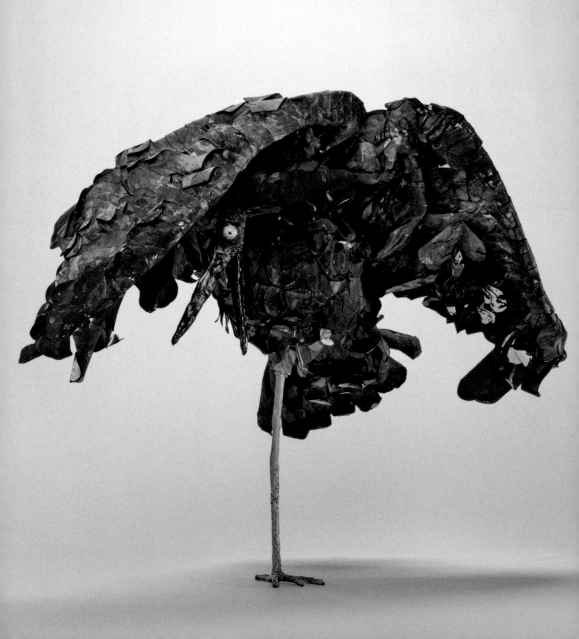

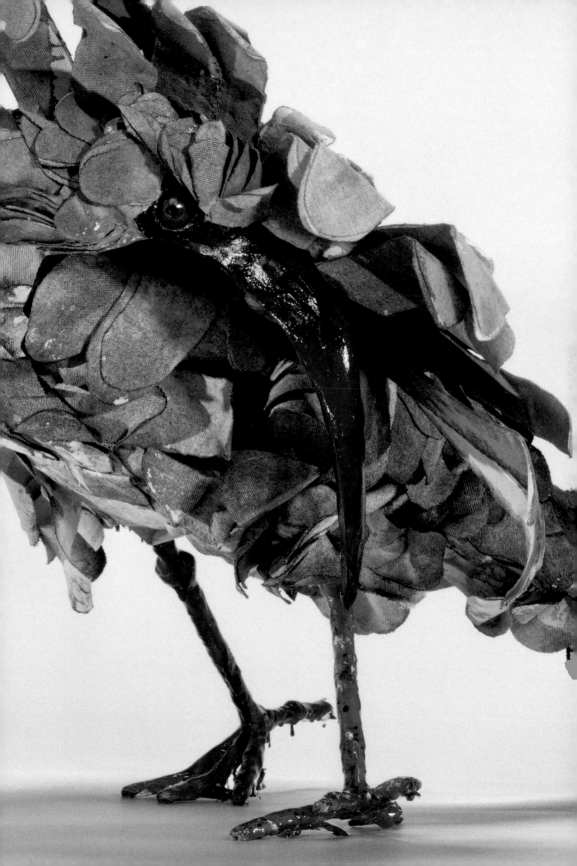

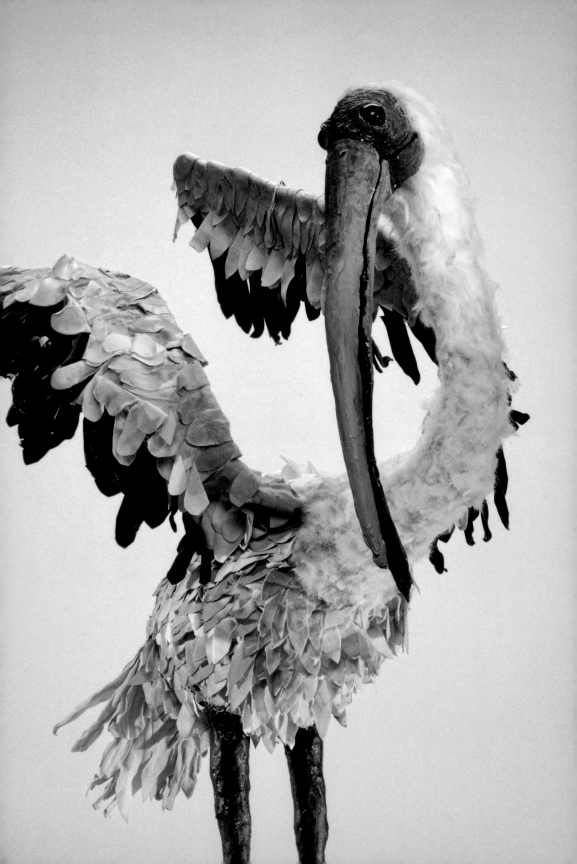

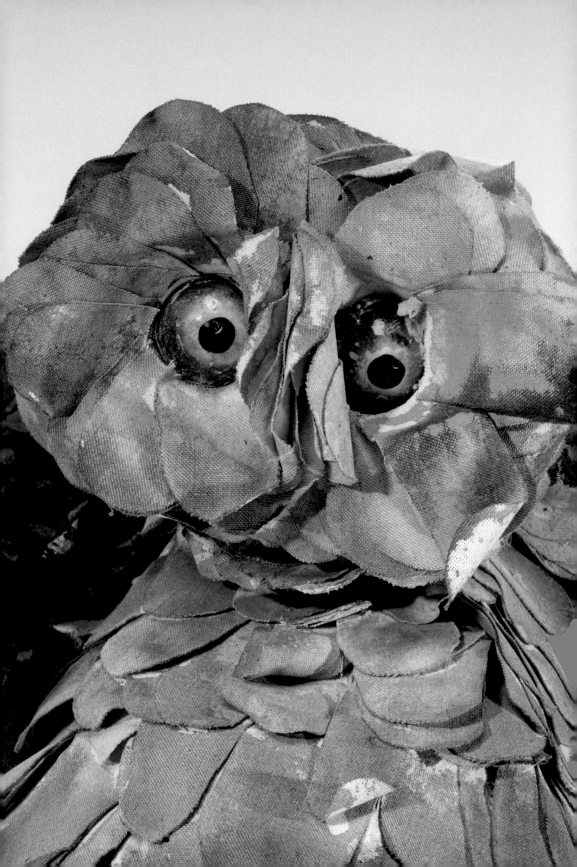

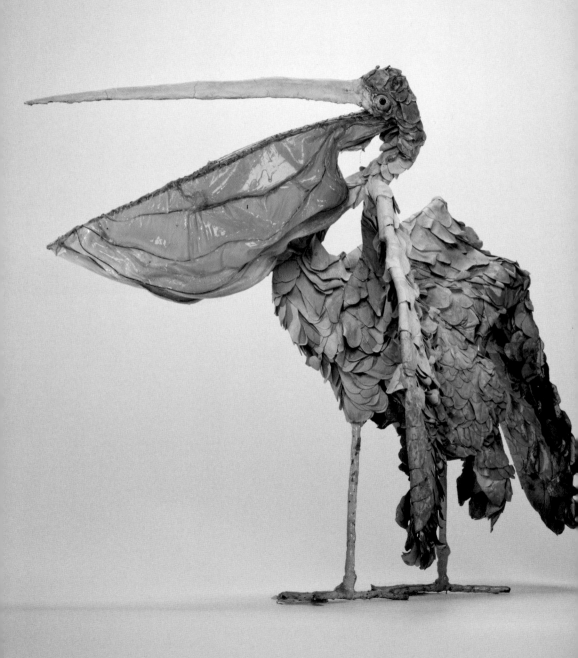

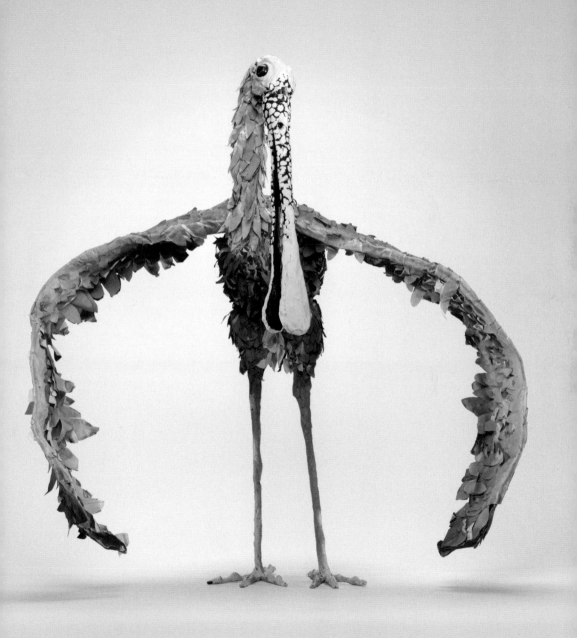

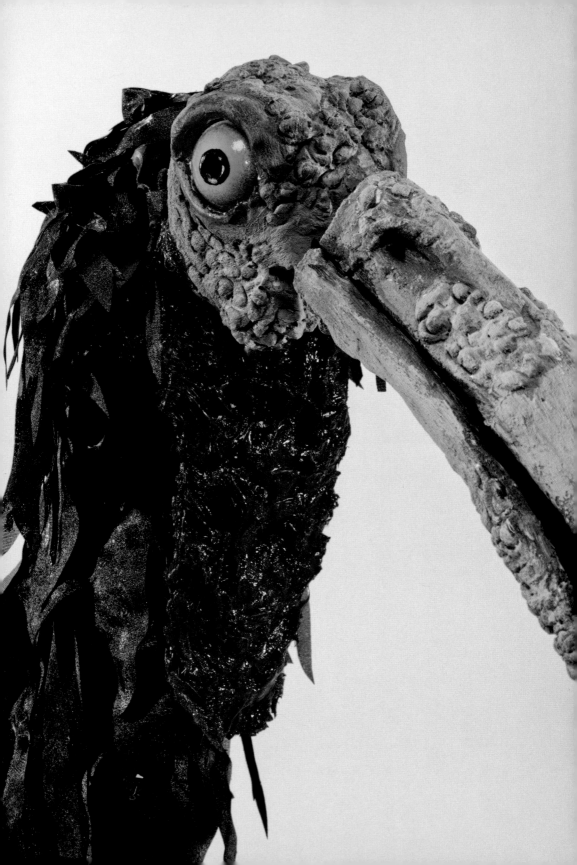

OPEN
WINDOW

Open window

Open window

A chalk drawing of a window flutters across a room, its color and shape shifting along a dark wall. At times it appears close and at others quite distant. A naked man stretched across the floor twitches, emerging from a deep slumber. Bleary-eyed and childlike, he searches for comfort, first by sucking on his knee and later on his thumb. Like a figment of his imagination, the window haunts him, hovering in the background. Anxiously, he rocks back and forth, arms crossed in a fetal position.

Without warning, multicolored feathers and a large pouched beak appear behind him. The miraculous bird arches its back, lets out a call, and envelops the man with its wings. Momentarily soothed by the animal's embrace, the man grows uneasy. The drawing of the window reappears, the creature is instantly distracted, and a foreboding tone hangs in the air. The window begins to migrate across the floor, circling them both. Diverted, the bird tracks it around the room as a cat might hunt a mouse.

The confused animal climbs atop the man's head to get a better view. When the bird flies toward the shifting window, the man seizes its legs. It struggles to free itself from his grip, and when it does, the man sucks his thumb and gestures longingly to the bird. A second opportunity presents itself, and when the man refuses to let go, he dangles helplessly from the bird's talons as it flies in pursuit of the elusive window.

Open window

Open window

Open window

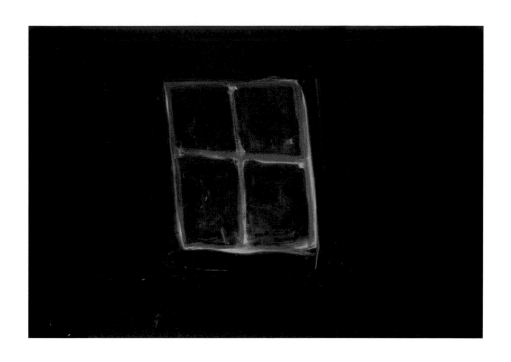

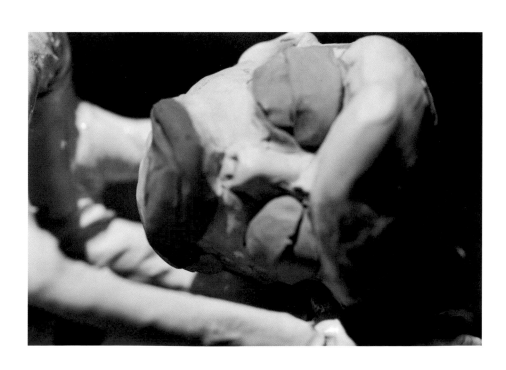

Open window

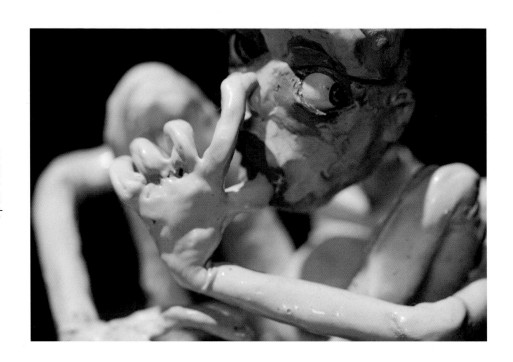

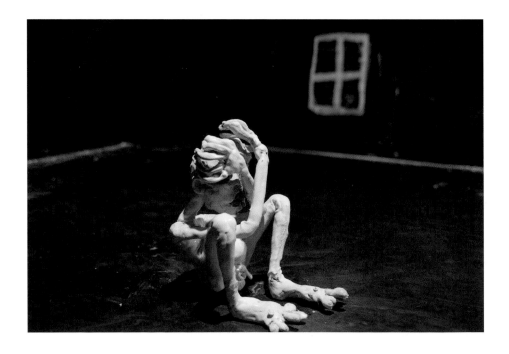

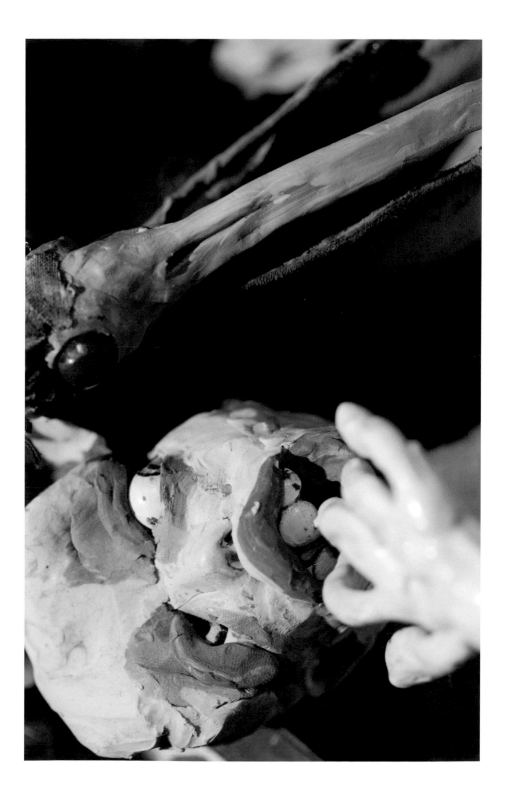

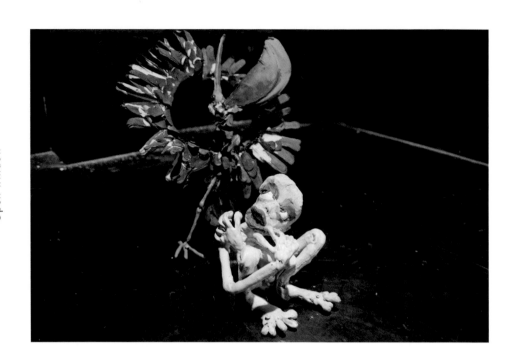

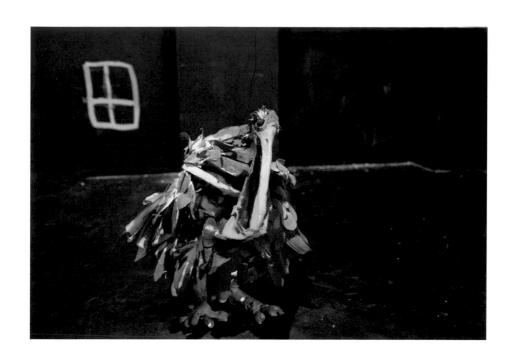

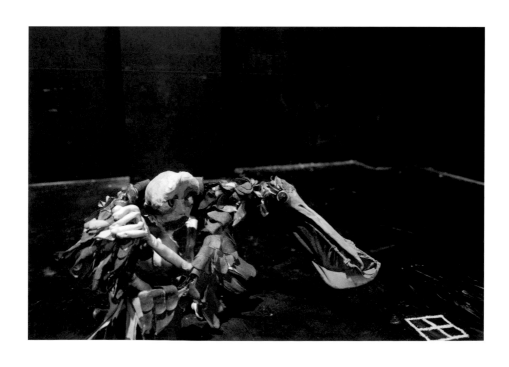

Open window

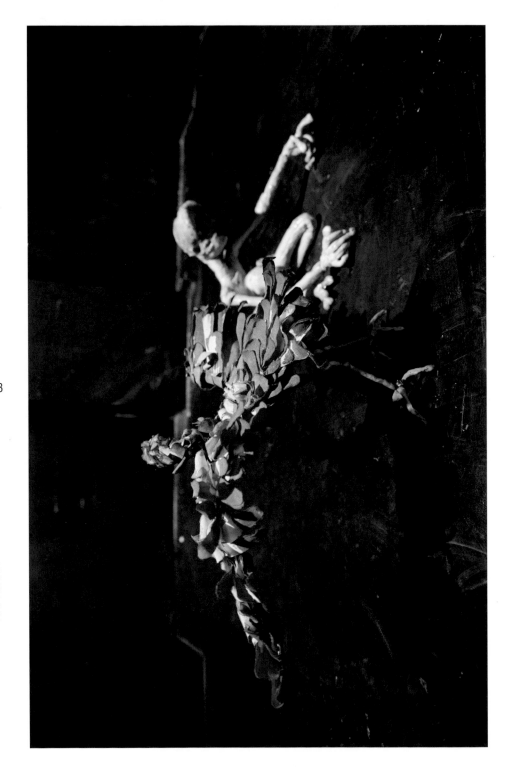

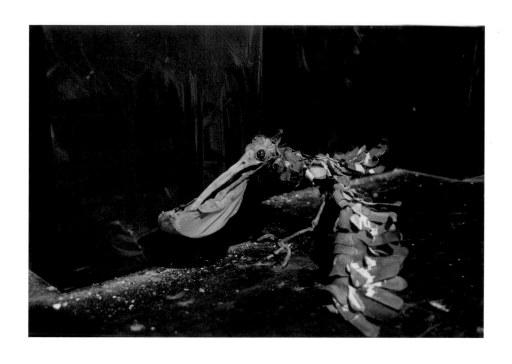

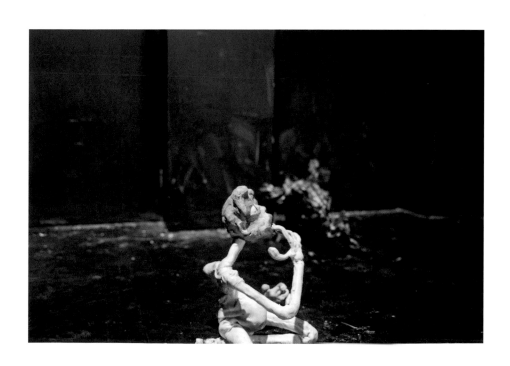

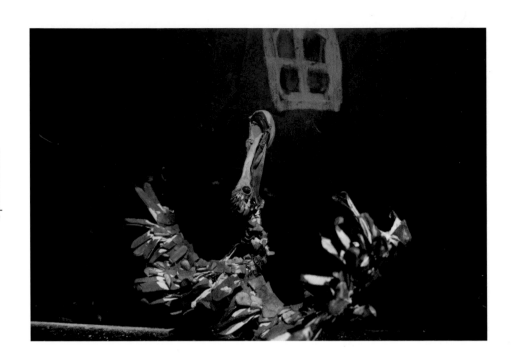

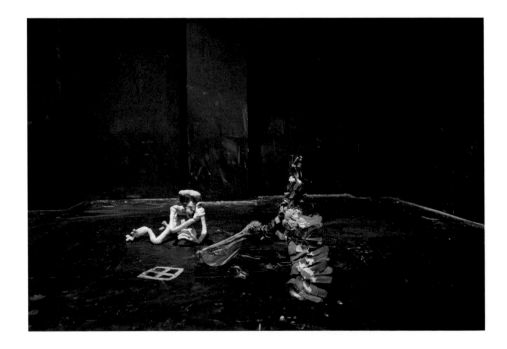

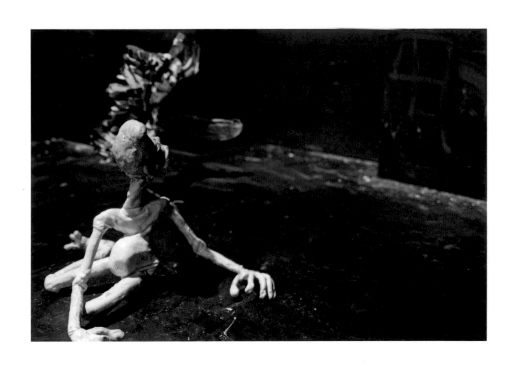

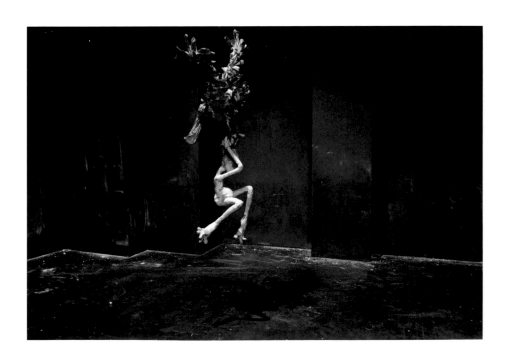

122

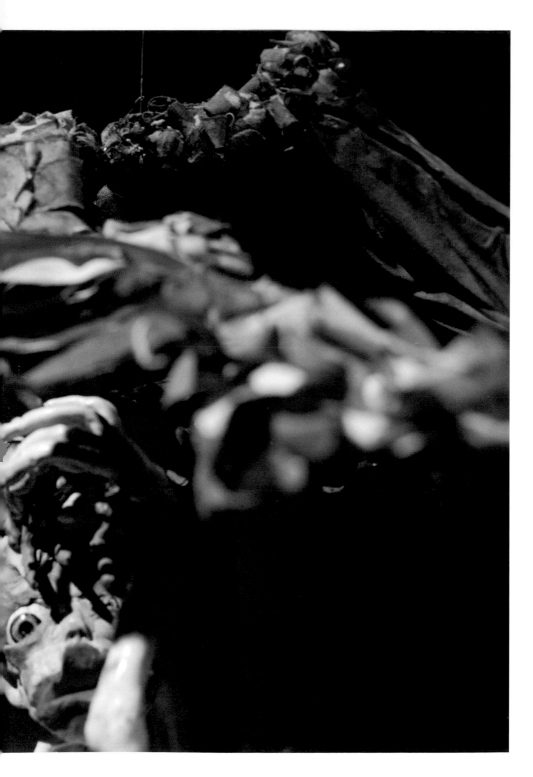

Open window

BaD EGGS

Three rotund women dressed in peasant garb surround a gurgling pot of soup. Huddled together, they wince and purse their misshapen lips as they slurp the tasteless green goo from a ladle. Not even another serving of vegetables will help, but when a scrawny, colorful bird flies overhead, they can't resist the opportunity to enhance their meal with a bit of fresh poultry.

Reaching into the sky with their spoons and forks, they capture their new ingredient. Killing the chicken, however, proves more difficult than they might have thought. They try to boil it alive. In self-defense, the fowl smothers one woman's face with its gaping throat pouch and spills the pot, staining their clothes. A drum beats as the frazzled women begin to strip, revealing their distended, naked bodies.

After they clean up the mess, the trio defeathers their prey, pausing to pick sharp quills from their own bare skin. The bird once again spills the pot, scalding its captors. Afraid, it seduces them into pitying it and satisfies their hunger by laying eggs—so many that they improvise an egg-drop soup. Stripped of its colorful plumage, the resourceful bird arches its back and lets out a plaintive cry that sounds almost canine.

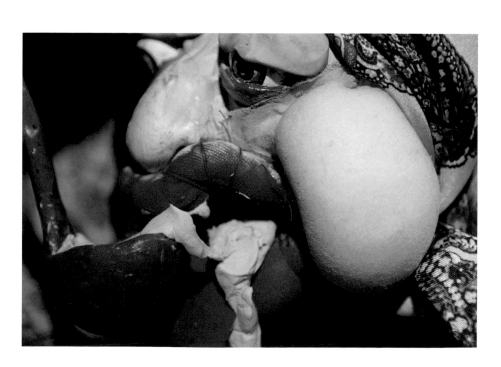

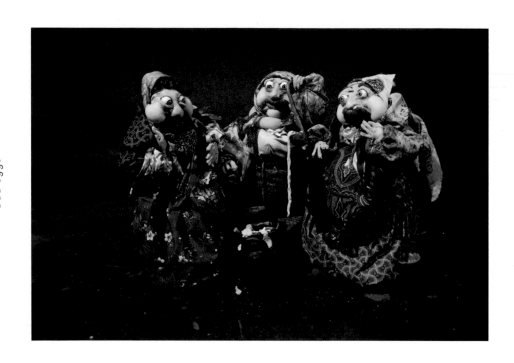

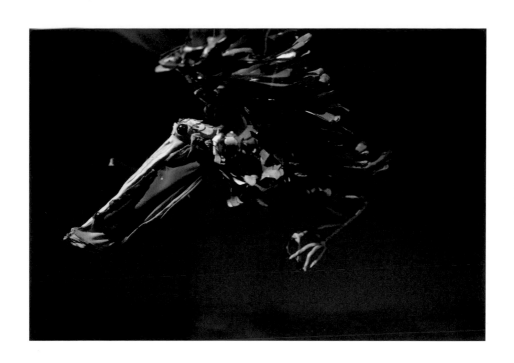

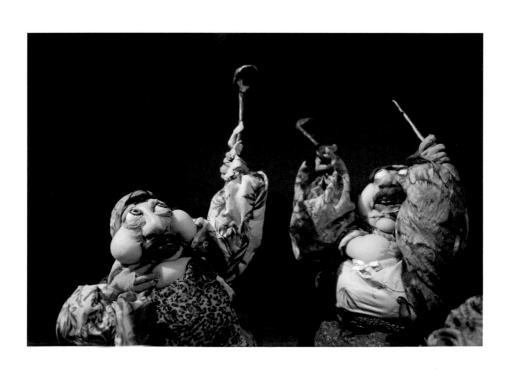

Bad eggs

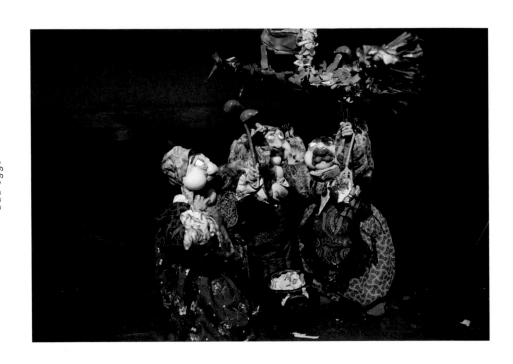

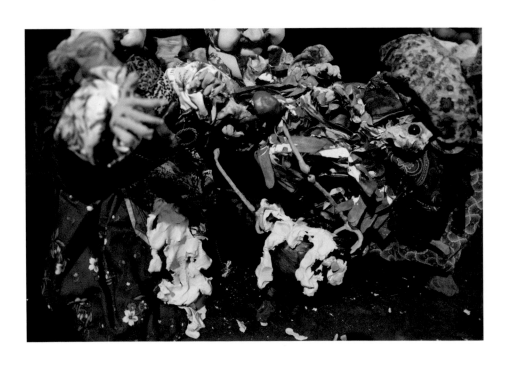

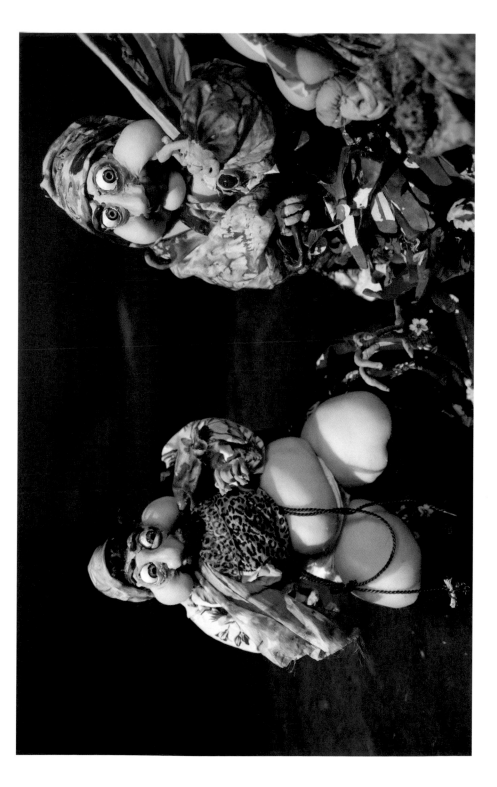

Bad eggs

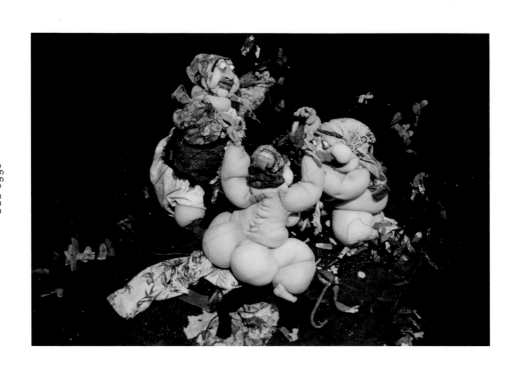

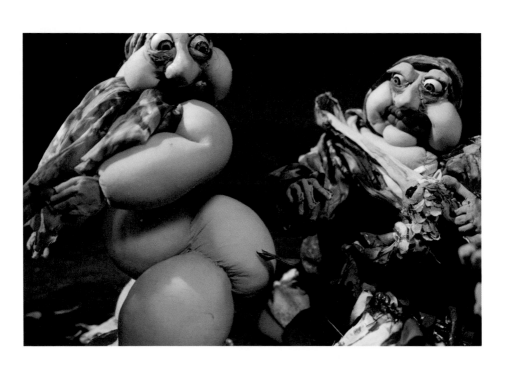

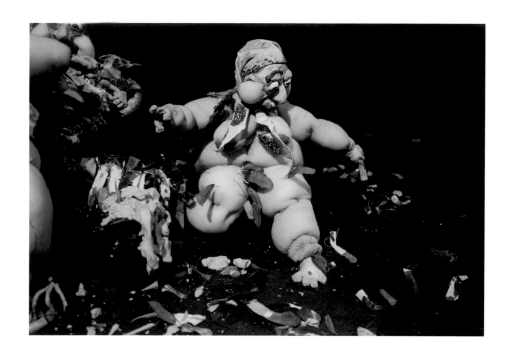

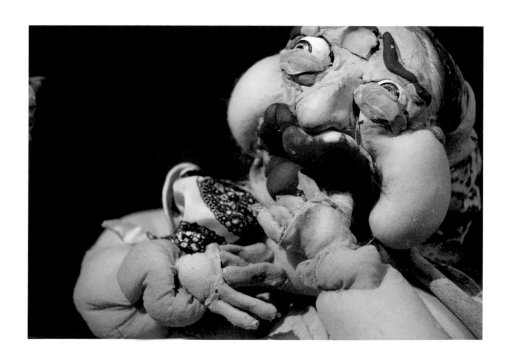

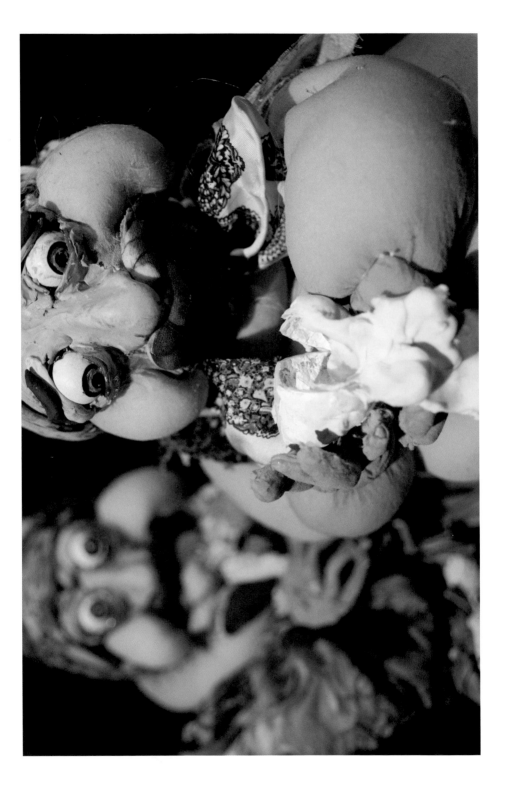

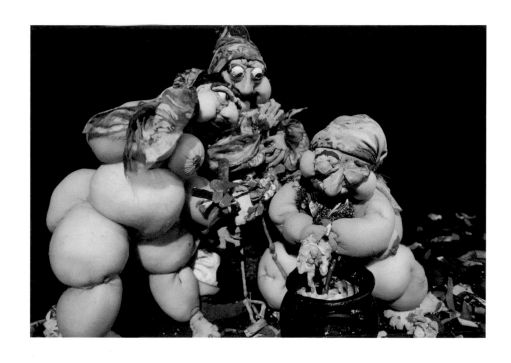

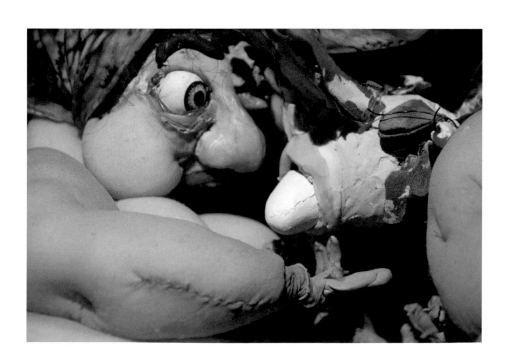

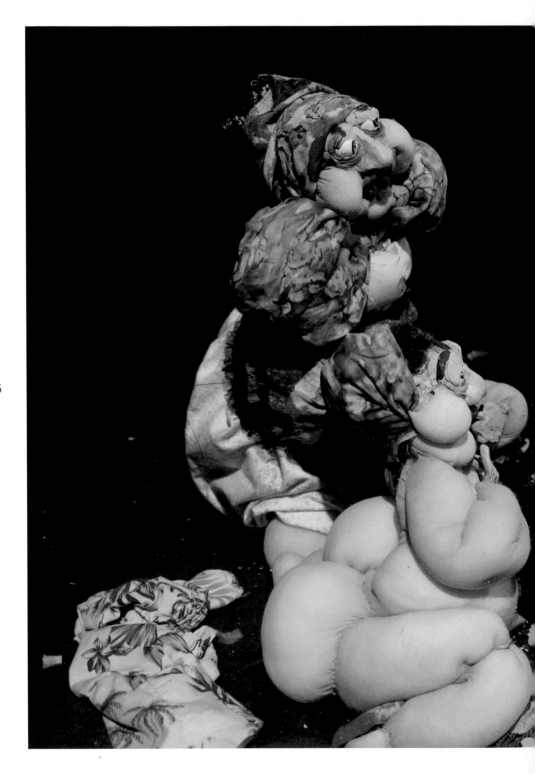

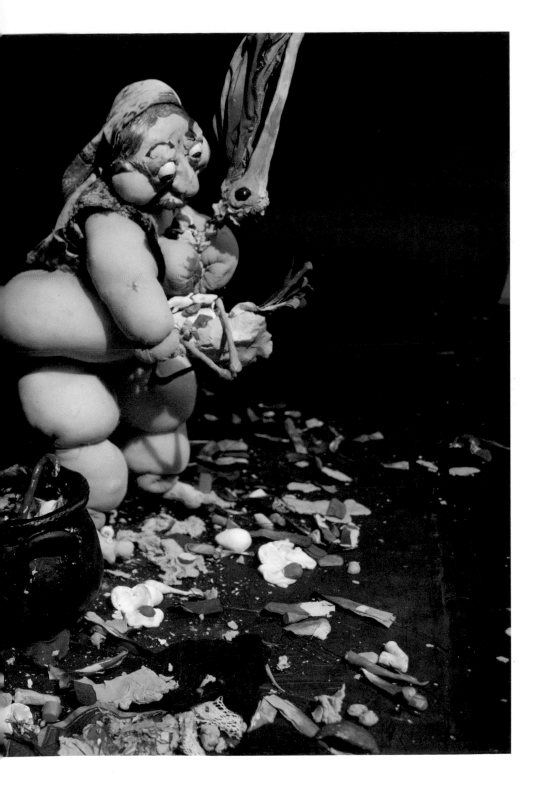

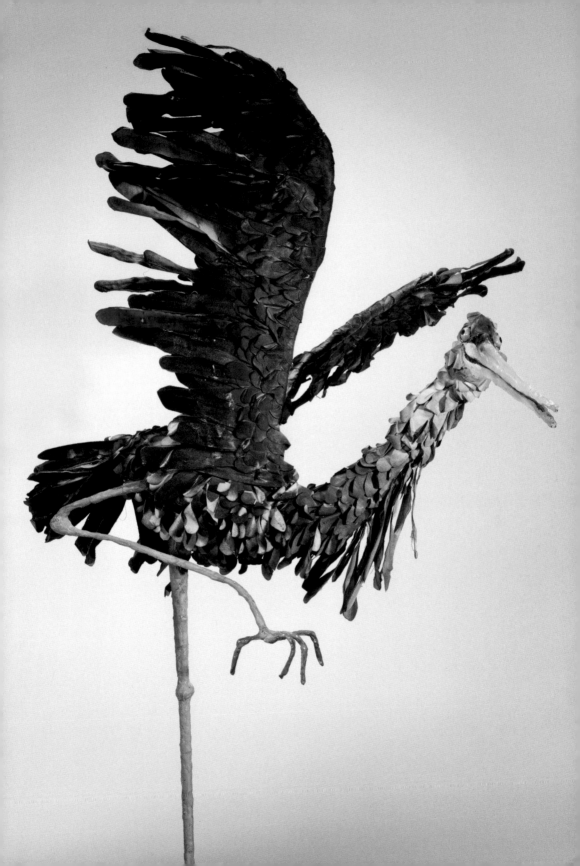

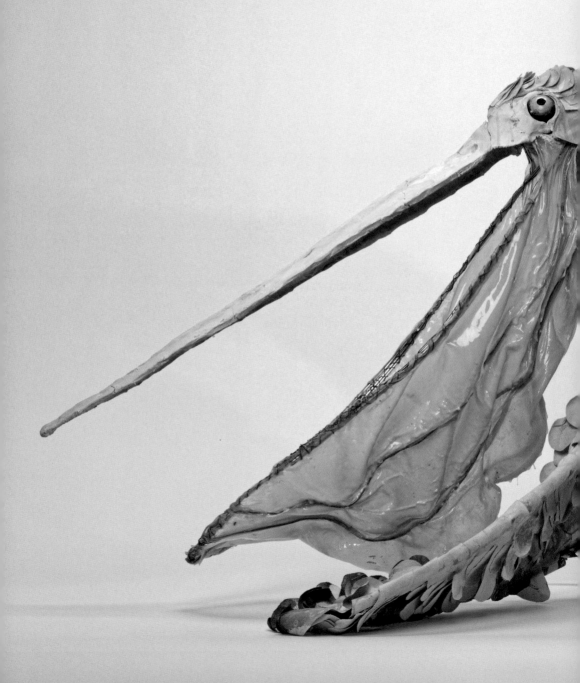

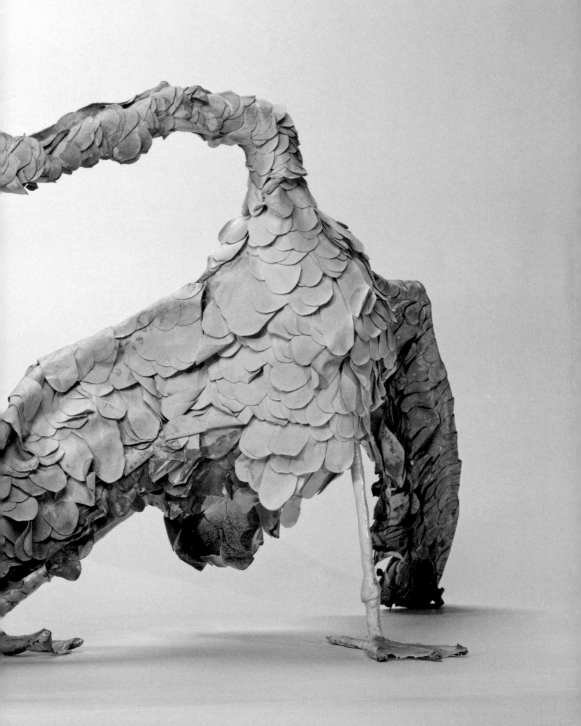

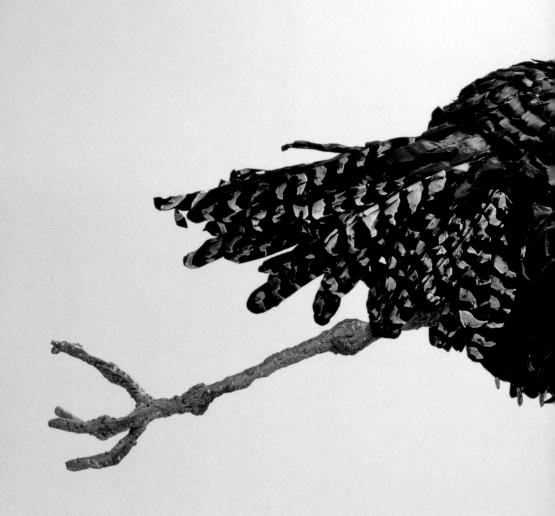

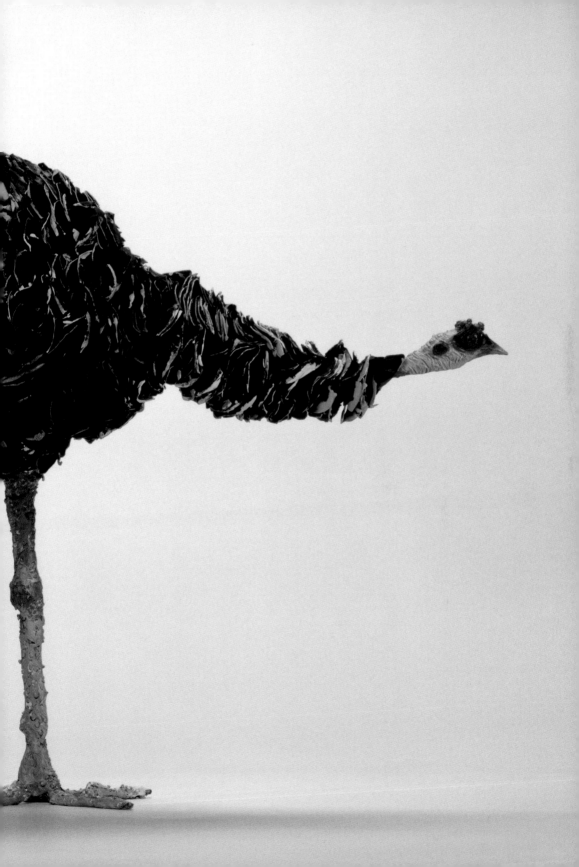

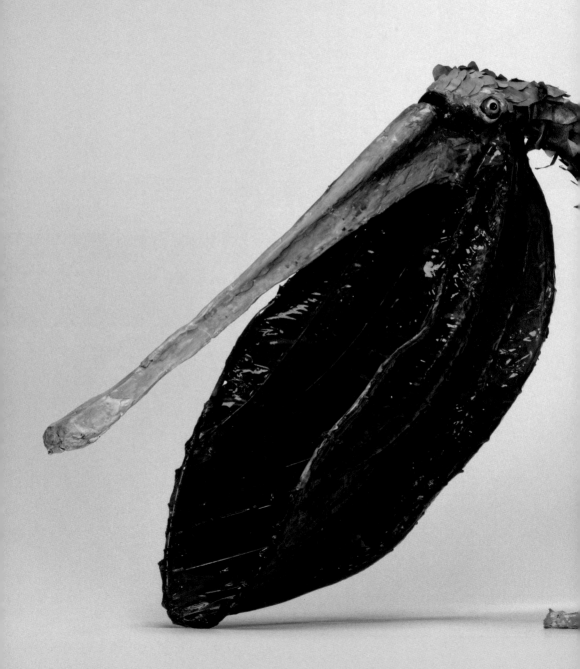

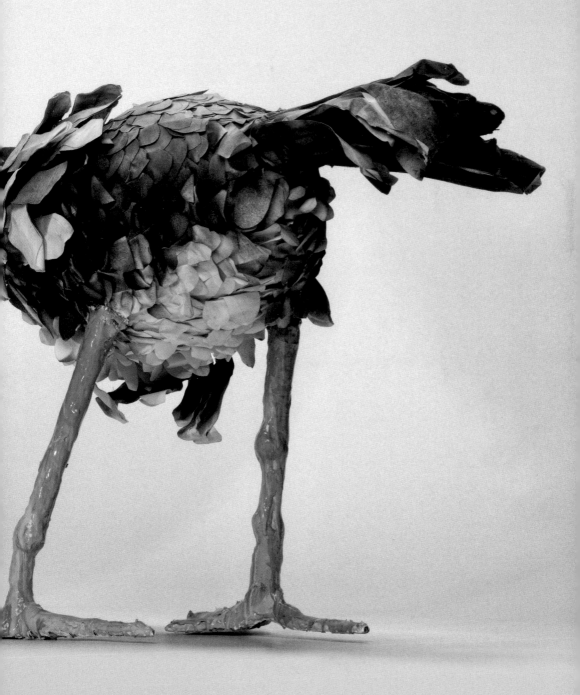

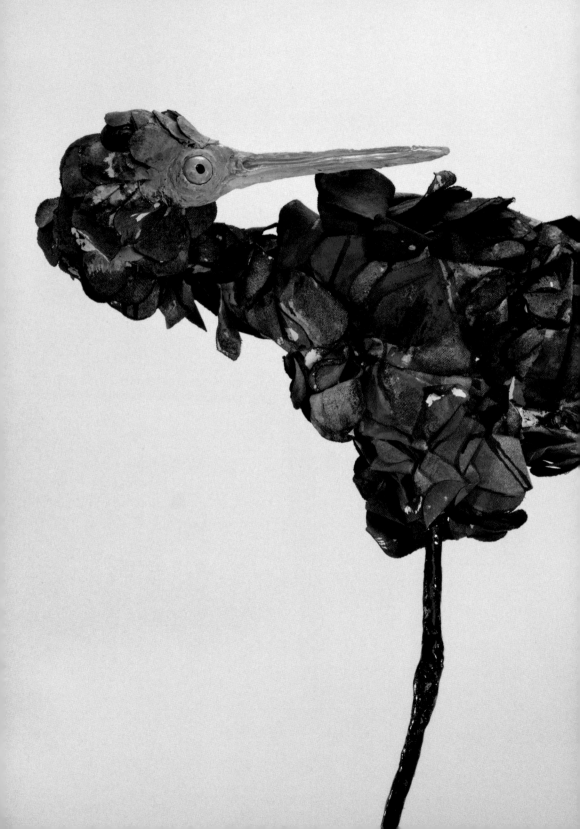

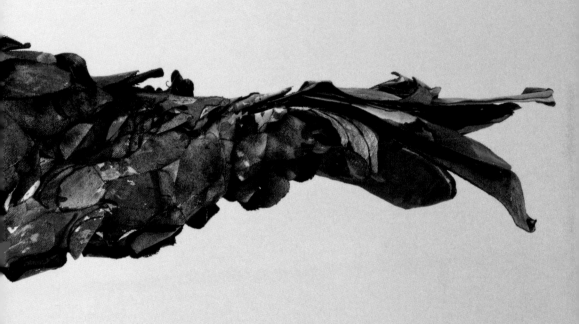

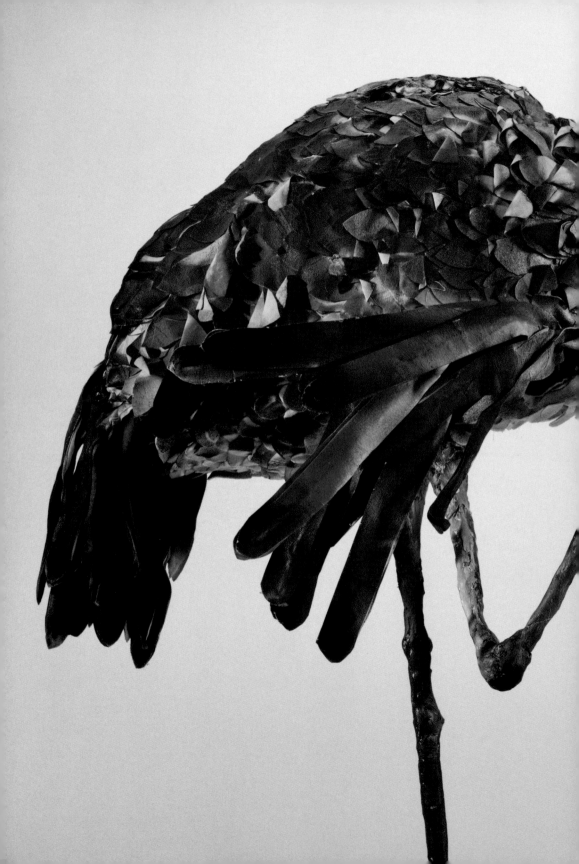

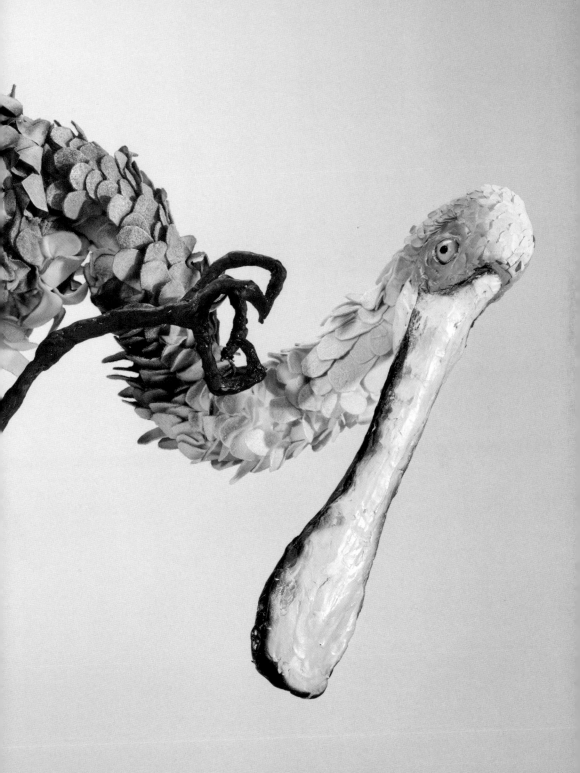

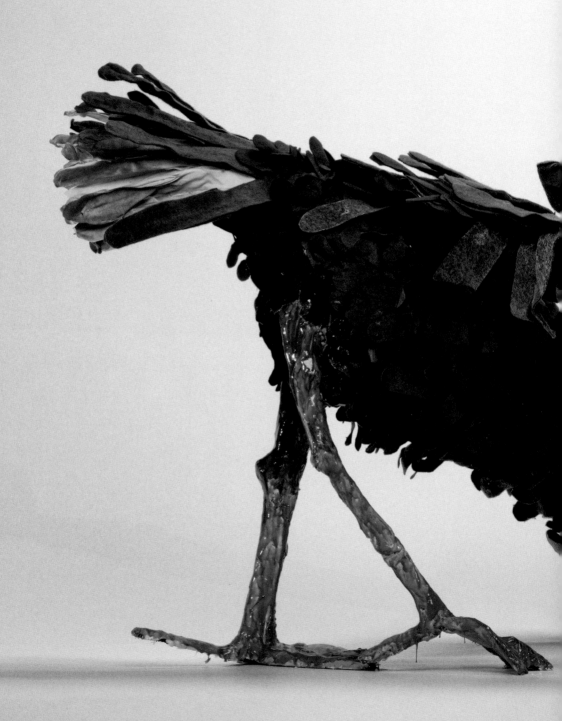

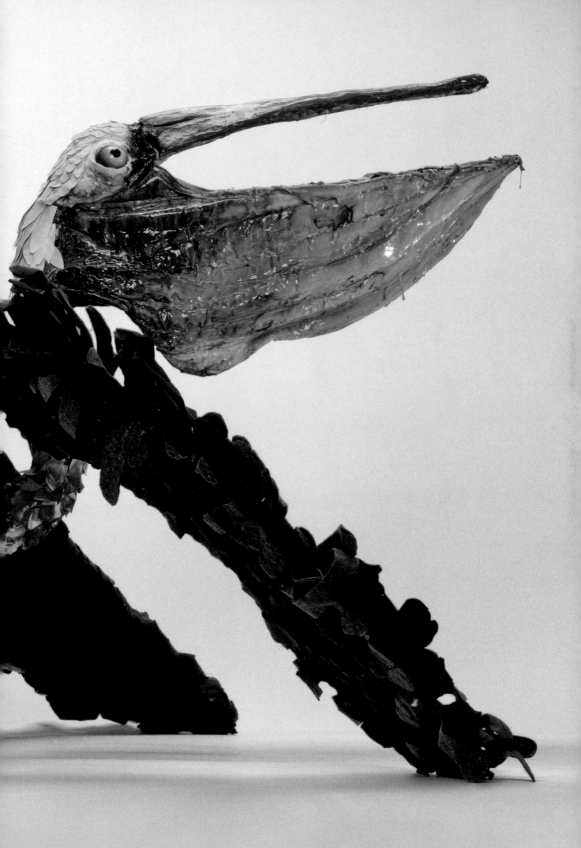

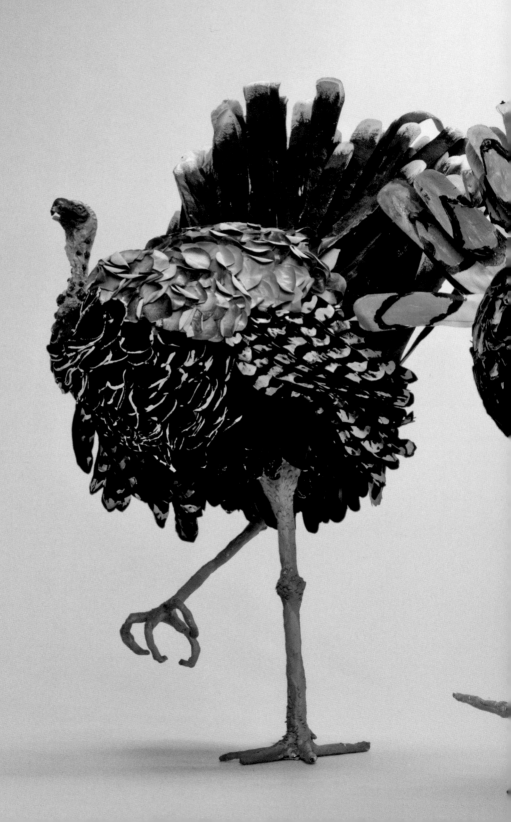

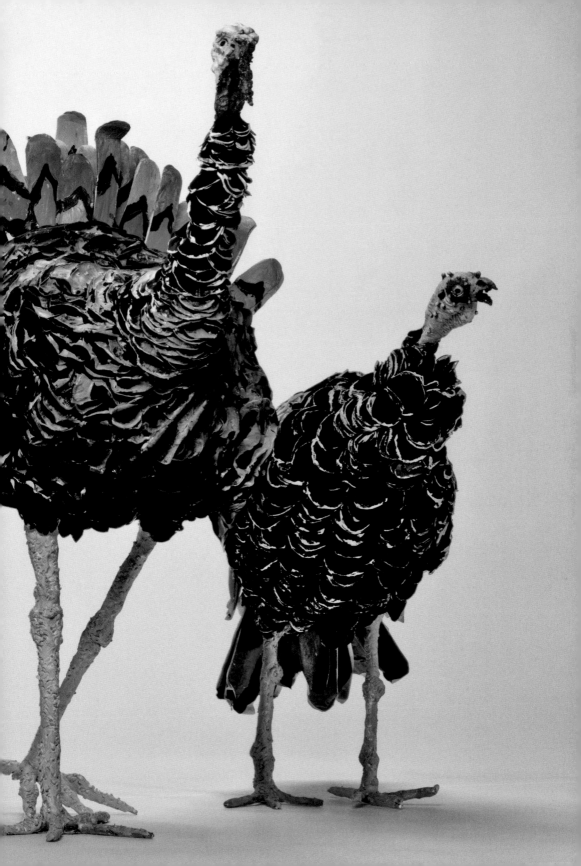

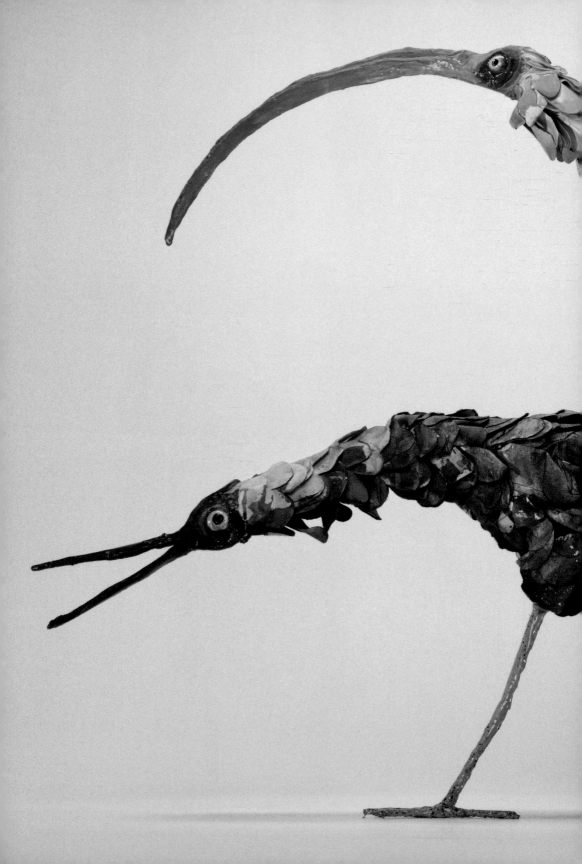

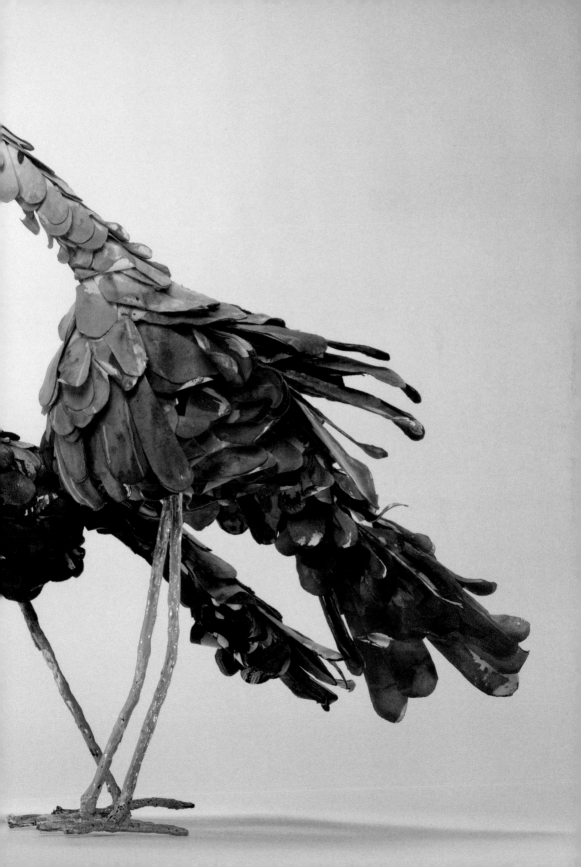

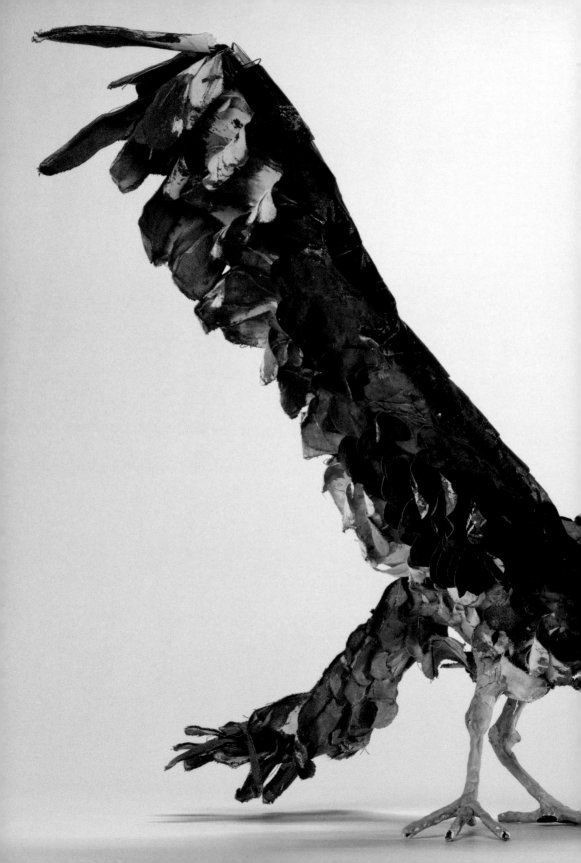

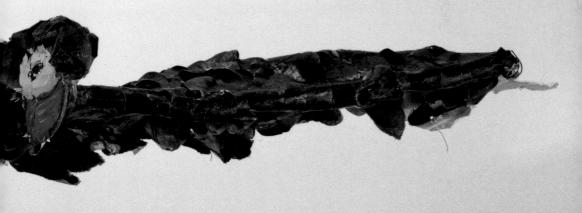

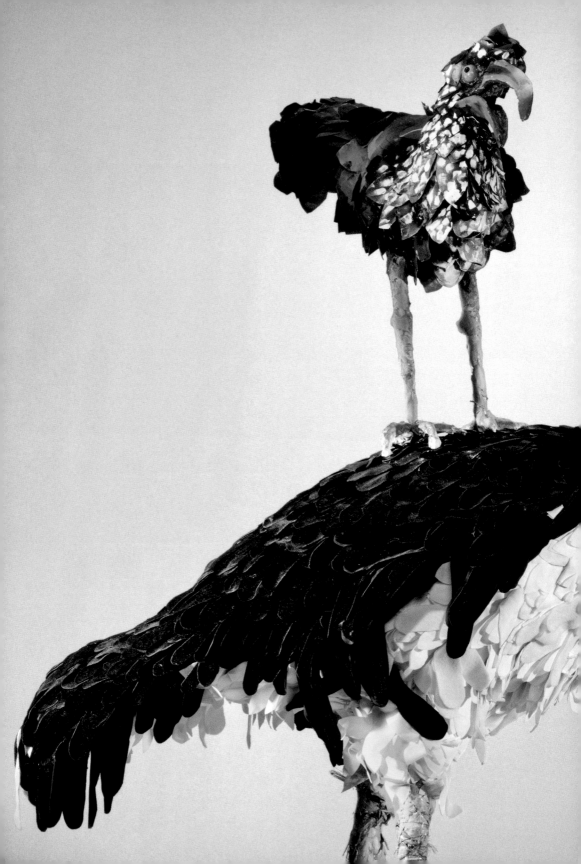

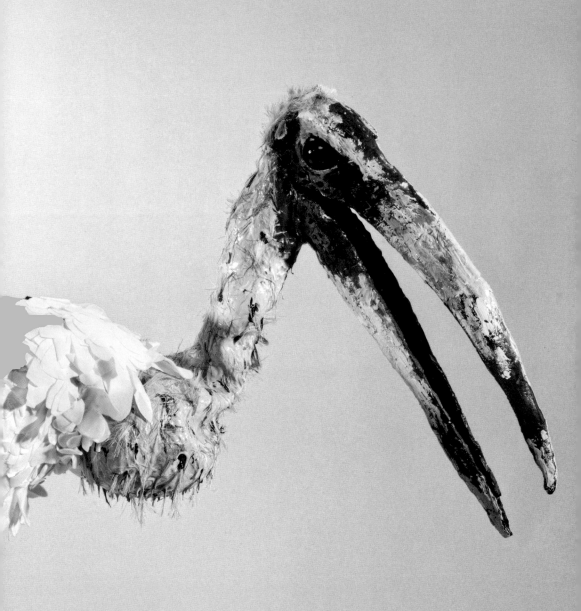

WILDeLIF

Eric Crosby

In spreading out his fan, this bird,
Whose plumage drags on the earth, I fear,
Appears more lovely than before,
But makes his derrière appear.

—Guillaume Apollinaire, "The Peacock"

Breast milk, cake frosting, melted wax, viscera, piss, blood, mud, and egg yolks—in Nathalie Djurberg's animated films, all manner of things take on a curious, viscous property. When bodies are severed and appendages snipped off, soft chromatic flows erupt. When the ground is excavated, miraculous hues begin to churn. When torture yields tears, pulsating blue corpuscles ooze forth, and when the body requires sustenance, a roiling pot of congealed soup will not satisfy. Fluidity is a material reality—a condition of the body's existence. Yet Djurberg's sculpted bodies are virtual; they are temporary containers for this strange substance. And the five films that comprise her installation, *The Parade* (2011), mercilessly squeeze it out of them. As a result, these works, taken together, allegorize a seldom valued function of art today: namely that it may give form to something hidden beneath the surface.

The notion of art as an expression of inner, subjective experience has a long history, often associated with nineteenth-century Romanticism when philosophers, poets, and artists turned away from Aristotelian notions of art as a form of imitation. No longer could the artist simply hold a mirror up to nature; instead, emotions and spiritual impressions of the world were to guide the artist's hand.[1] By the turn of the twentieth century, this conception of art became inextricably tied to Sigmund Freud's discovery of the human unconscious. Inner life, fantasies, and aspects of the psyche previously untapped became the province of art. Like a dream, the artist's vision took the shape of a rebus.

This displacement of an art of mimicry by an art of the unconscious mind would generate much critical fodder over the nineteenth and early twentieth centuries, most of it aimed at validating the artist as an intuitive creator. In 1940, for example, Ludwig Wittgenstein articulated a version of this distinction in his private journal. "Within all great art there is a WILD animal: *tamed*," he writes. "All great art has man's primitive drives as its groundbass." For Wittgenstein, if an artist's creations are nothing more than the product of *"good manners"* and "great [cultural] *understanding*," then they only fulfill a *"reproductive"* function. Such art is "unhealthy" for society, he argues. The alternative is to conceive art as an uninhibited *"primordial"* activity—as "wild life striving to erupt into the open."[2]

Today, this distinction between a "reproductive" artist and one who embraces "wild life" sounds a bit outmoded, especially in an art world often skeptical of claims to the mystical, instinctive, or subjective. It nevertheless retains a degree of critical and historical relevance, particularly in relation to a diverse lineage of artists whose sculptural and performative practices have embraced unconscious impulses after art's conceptual turn in the 1960s. From the desiccated body casts of Paul Thek and the accumulated phalluses of Yayoi Kusama to the ritualistic performance works of Carolee Schneemann and the Viennese Actionists, among many others—the visionary impulse, the dream image, and what Carl Jung calls the "active imagination" all trump conscious thought. For its dark subjectivity and eccentric materiality, Djurberg's art belongs to such a lineage.

In a world where critical distance has been a valued aesthetic strategy, hers is an art of immediacy—material, physical, emotional, psychological, sexual. It runs willfully against our time—nothing else seems quite like it. Rooted in narrative and figuration, her persistent subject is the human body twisted and torn, pushed beyond its limits, and her vivid stop-motion animations dramatize hidden urges and primal scenes. The immersive sculptural settings that house these films offer us viewing scenarios that conflate the transgressions of her characters with the conditions of our own spectatorship. Yet as much as her art grapples with our darker impulses (the work is often mischaracterized as "gothic"), it also concerns itself with expansive and ineffable questions about human experience and the creative process.

At the core of her art is a deep-seated desire to realize the transformative potential of material and, by extension, human subjectivity. It is within this dialectic—a conflict between surface and depth, substance and psyche—that her work achieves its potency today. Italian philosopher Giorgio Agamben has argued that the state of being contemporary is not one of synchronicity, but rather of courageous disjunction and anachronism—the state of being at odds with one's time. Such "dys-chrony" allows the individual to see what her epoch might aim to hide. "The contemporary," Agamben writes, "is [she] who firmly holds [her] gaze on [her] own time so as to perceive not its light, but rather its darkness.... The contemporary is precisely the person who knows how to see this obscurity, who is able to write by dipping

[her] pen in the obscurity of the present."[3] For her attention to the behaviors of the social body—its tendency toward abuse and hypocrisy, its mendacious assurances of benign intent, and its willing inclination to deny, repress, and sublimate its own cruelty—Djurberg writes the darkness of her day, laying bare humanity's duplicity and forcing us to reckon with those aspects of our experience we refuse to live honestly. For Agamben, the contemporary's attention is turned toward such "unlived" facets of life, such as the distant exploitation of others, and Djurberg's puppets serve as our surrogates enacting these traumas again and again.

Frustrated by her studies in sculpture and painting, Djurberg taught herself how to make films in art school. Animation allowed her to produce compositions in motion, such as her first film, the two-minute short *Untitled (Sunset)* (1999), which depicts a nearly abstract play of oil paint on a single surface. By stitching together a sequence of images, the animated film foregrounds transformation over composition, movement over stasis—no single image is more important than another. Over the years, her moving images have become more and more elaborate, deploying clay and plasticine figures in detailed settings. Despite their complexity, Djurberg works without an assistant. Her only collaborator is Hans Berg, a self-taught musician and electronic music producer who has scored all of her videos since the two met in 2004. Their partnership has been a symbiotic one. Like Djurberg, Berg works in a similarly intuitive mode, often avoiding technical polish in favor of emotional expression. "Since the films aren't perfectly made, it would be strange if the music was," he writes. "They wouldn't work together." Drawing from a number of sources, including folk and classical music, Berg builds layered tracks with digital effects to produce highly stylized, often unsettling compositions. Such scoring can reinforce the emotional tenor of a film or push it in a new direction. Berg explains, "I can choose to go with the film, illustrate what is happening in the narration, or to go opposite of what you see, which can make a very strong and awkward effect; you get mixed signals from your eyes and from your ears and feel something is wrong, but you can't really put your finger on what, exactly."[4]

Increasingly, the worlds depicted in Djurberg's films have begun to project outward, taking shape in large-scale installations.

For *The Experiment* (2009), the duo's project at the 2009 Venice Biennale, Djurberg constructed a dense and sinister garden of fecund alien plants, bursting with seeds, their surfaces glistening with a viscous glaze (fig. 1). Amid these creations, she projected three films depicting brutal scenarios of suffering, sexual trauma, and greed. If her films harness neurotic energy, then the objects in these environments appear as their symptoms. Her salivating flowers do not derive nourishment from the sun, but rather from the abuses flickering in the images amongst them. For *Snakes knows it's yoga* (2010), she presented forty-two plasticine sculptures of yogis and mystics enacting rituals of self-punishment in plexiglass vitrines (fig. 2). Two nearby films depict a meditating man being torn apart by a snake and a woman hallucinating from the poisonous venom of a frog. Of the relationship between her films and her sculptures in such sprawling environments, Djurberg has said, "In [the] films you have a timeline: something is happening and you can see that. The puppets or sculptures, on the other hand, don't have a timeline. They are like fragmented aesthetics, with every possibility still in them. It is clear that something has happened, but you only have this fragment, and nothing around it. It's a universe of frozen moments."[5]

The space of the artists' installation, *The Parade*, is populated by more than eighty birdlike creatures—assembled from wire, foam, glues and silicone, painted fabric, and clay. The modesty of their material composition belies the unnerving effect of the flock, for these are sculptures that stare back with beady eyes that meet one's gaze at every turn. While they bear the outward appearance of birds, their features, upon closer inspection, reveal a process of forced evolution. They exist in a state of becoming something else. Working from images of real species, the artist has abstracted generic types from essential characteristics, intensifying and exaggerating their appearance. Their coloration is flamboyant, even acrid. Skins look scaly and reptilian. Hair and fur sprout where feathers should be. Gaping maws are covered with blood. Carbuncles, boils, and other dysmorphic features disfigure their bodies. At once alluring and corroded, the surfaces of these creatures entice us to look closer, and when we do, these characteristics begin to recede as Djurberg's humble materials come forward. Feathers are made of bits of hand-painted fabric. Talons are

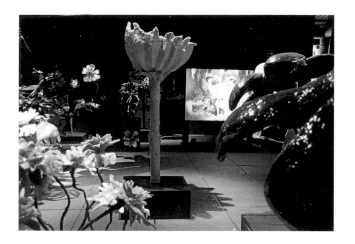

(fig. 1)

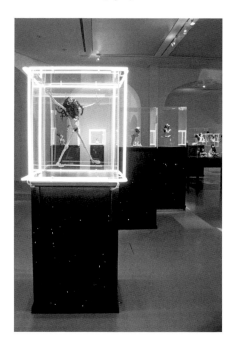

(fig. 2)

(fig. 1) Installation view of Nathalie Djurberg's *The Experiment* (2009) with music by Hans Berg in *Fare Mondi/Making Worlds*, the 53rd International Art Exhibition of the Venice Biennale

(fig. 2) Installation view of Nathalie Djurberg's *Snakes knows it's yoga* (2010) with music by Hans Berg, kestnergesellschaft, Hannover, Germany

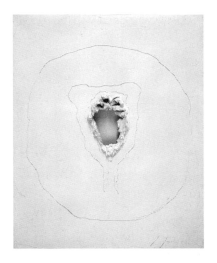

(fig. 3)

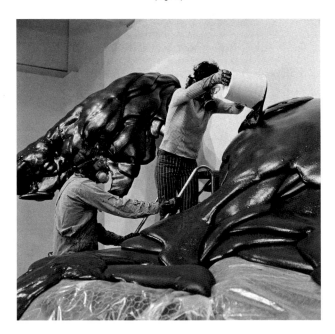

(fig. 4)

(fig. 3) Lucio Fontana *Concetto Spaziale (Spatial Concept)* 1968

(fig. 4) Lynda Benglis creating *Adhesive Products* (1971) for the exhibition *New Work for New Spaces*, Walker Art Center, 1971

nothing more than hardened modeling clay. Painted wooden eyeballs stare vacantly. Raw cotton, faux fur, and hair. Spray paint and silicone. Brush marks and fingerprints everywhere. These are not birds; they are abstract paintings.

"I go back to painting over and over again," Djurberg has said recently.[6] It isn't hard to see the fleshy impasto of Philip Guston, the base materialism of Lucio Fontana (fig. 3), the poured stains of Morris Louis, the polyurethane flows of Lynda Benglis (fig. 4), or the atmospheric palette of Francisco Goya in the textures of her objects or the movement of her films. Yet however painterly her sculptures appear, her interest in the medium is not simply a matter of form. What attracts Djurberg to the act of painting is a modality of experience distinctly at odds with the procedures of stop-motion animation—in particular, the creative sensation of fascination and immersion, of existing out of time in relation to the work, of distraction. Animation constrains the creative process with a rhythm: each setup is considered and resolved before it is photographed. Painting, on the other hand, offers a field that is constantly in a state of becoming, its evolution unbounded.

Contrary to those who have located painting in a triangular relationship with the hand and the mind, Jacques Lacan has understood the medium as a function of desire, as a screen locked between what he calls the gaze and the painting's subject of representation. In his lecture titled "What Is a Picture?" Lacan remarks on a slow-motion film of Henri Matisse painting—the sequence distending each gesture in time, making each mark appear deliberate. Yet the film is an illusion. He writes, "What occurs as these strokes, which go to make up the miracle of the picture, fall like rain from the painter's brush is not choice but something else.... If a bird were to paint would it not be by letting fall its feathers, a snake by casting off its scales, a tree by letting fall its leaves?" For Lacan, the fascinating power of the picture extends to the status of the mark not as a product of conscious agency (for the mark is something that "falls") but rather as an effect of a latent desire to satisfy the "appetite of the eye on the part of the person looking."[7] The act of painting, then, can be understood as something akin to hypnosis, whereby facets of the unconscious mind come to settle on the surface of the composition in the service of the gaze.

In this respect, Djurberg's constructions tempt an immersive form of looking on our part, perhaps even fixation. Equal parts creature and sculpture, they have surfaces that seem at once evolved and invented. This is especially true of those specimens that resist mimesis aggressively, those whose distinct avian characteristics have been masked by an accumulation of alien features. Djurberg has recently characterized her film work as "becoming more abstract,"[8] and this is also true of her objects. As this body of work developed, each piece tended to depart further from its referent toward an eccentric and hybrid mode of painterly abstraction. Yet despite all of their differences, the birds are a symptom of the artist's own neurotic compulsion toward repetition and accumulation. In one of her best-known early films, *Tiger Licking Girl's Butt* (2004), an intertitle flashes: "Why do I have this urge to do these things over and over again?" The question lies at the heart of Djurberg's practice, which always deflects an easy answer. Repetition may yield pleasure, but as Freud has explained, it can also be a defense mechanism, an attempt to circumvent the return of repressed desires and unfulfilled wishes, which may percolate to the brink of consciousness in dreams, jokes, and parapraxis.[9] Like Freud's dream-work, Djurberg's art thrives on symbols and archetypes, but here they do not function in the service of psychic censorship; rather, the repressed returns in Djurberg's art as surface— raw and exposed.

For this reason, her work bears an affinity to that of Yayoi Kusama, whose art is characterized, first and foremost, by compulsive accumulation. Nets, flowers, faces, polka dots, phalluses—the Japanese artist's desire to repeat and amass these forms over her career, she insists, stems directly from terrifying childhood visions of being overcome by such shapes. "My art originates from hallucinations only I can see," she writes. "I translate the hallucinations and obsessional images that plague me into sculptures and paintings."[10] The resulting works, many of which Kusama conceived as eccentric, theatrical environments, were intended to alleviate the burden of her neuroses. She called her practice "art-medicine" for its therapeutic iteration of gesture and form,[11] producing countless photographs and collages depicting her figure as inseparable from, indeed consumed by, her own work (fig. 5).

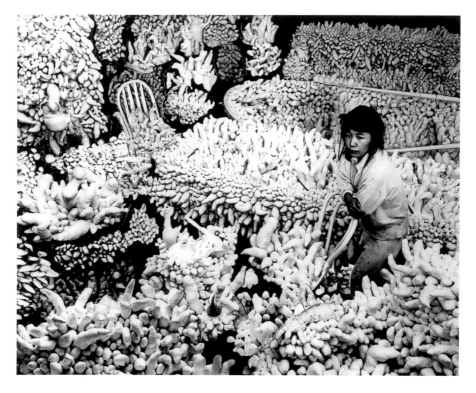

(fig. 5)

Yayoi Kusama *Compulsion Furniture (Accumulation)* 1964

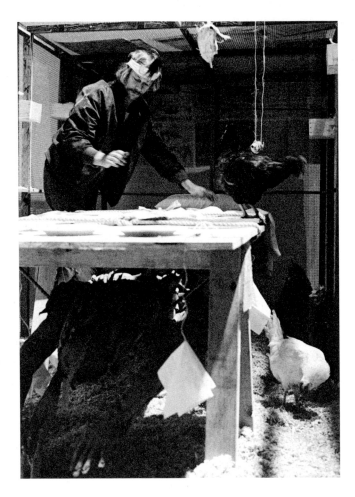

(fig. 6)

Paul Thek installing *Fishman* (1969) for the exhibition *Figures/Environments,* Walker Art Center, 1970

Themes of anxiety, repetition, and sexual panic course throughout Djurberg's environments as well. When asked where her work comes from, she has often tried to characterize the practice as a means of "venting my aggressions" or more broadly "as a way to cope with reality, to make it clear to myself." [12] With her belief in a cathartic function of artistic practice, Djurberg is, in many ways, what Kusama would call "a heretic of the art world"—one whose work is so private that it seems to exist only for the artist. [13] For its deeply personal iconography and intimate mode of construction, Paul Thek's art is also crucial in this respect. Starting in the late 1960s, he moved away from making discrete sculptures resembling slabs of meat encased in minimalist glass vitrines in favor of a generative, sometimes performative mode of installation. Casting parts of his own body in latex, he entombed his figure in complex ephemeral environments that variously evoked workspaces, chicken coops, and sacramental banquets (fig. 6). Sometimes evolving over the course of their exhibition, Thek's installations were conceived ritualistically as a procession, or to borrow Djurberg's term, a "parade." For one installation called *A Procession in Honor of Aesthetic Progress: Objects to Theoretically Wear, Carry, Pull, or Wave* (1968), Thek assembled a large palanquin, chairs equipped with shoulder braces, and other items adorned with taxidermic crows and fake flesh. He used the space not only as a stage for the evolution of his objects, but also for a series of private performances involving his own nude body and a dead vulture. [14]

Like Thek's iconography, Djurberg's symbols, characters, and scenarios are intensely personal, generally culled from the artist's lived experience. They come to her first as archetypes, but always seem to find their specificity through narratives, which often center on the sadistic behavior of the social body. In *Feed All the Hungry Little Children* (2007), menacing shit-stained kids compete for the attention of a prostitute. Only her breast milk can satisfy their collective hunger. In *It's the Mother* (2008), five maniacal children force their way back into their mother's womb despite her struggle and tears. Possessed, her figure morphs into an expressionless automaton. In *Hungry Hungry Hippos* (2007), three obese flatulent women in lace lingerie demand kisses from a little boy and smother him aggressively. When he inquisitively pokes at their bodies, they

shut him in a locker. In these and many other short films, the agency of the individual is subordinated to the psychology of the group, and the group's tendencies are to bully, pester, consume, even murder.

And so we encounter Djurberg's current flock not only as a proliferation of vibrant, mutating surfaces but also as a threatening horde. The exhibition space does not belong to us; it belongs to them. When birds congregate, they do so to defend against predation as well as to forage and migrate. Their assembly is a territorial display. The term *parade* generally refers to a celebratory procession of individuals, but the term also has martial connotations. The military parade, a ritualized derivation of combat, is intended to intimidate through a symbolic projection of power. In 1941, George Orwell, then writing about the war in England, remarked on this "ritual dance," suggesting that the style of a country's parade-step is a clear indicator of its social temperament: "The goose-step, for instance, is one of the most horrible sights in the world, far more terrifying than a dive-bomber. It is simply an affirmation of naked power; contained in it, quite consciously and intentionally, is the vision of a boot crashing down on a face. Its ugliness is part of its essence, for what it is saying is 'Yes, I am ugly, and you daren't laugh at me,' like the bully who makes faces at his victim." [15]

Beyond intimidation and might, the flock also has sexual implications, for the sociality of animals is generally in the service of species propagation. Avian mating behavior involves some courtship display of plumage on the part of the male accompanied by a dance and sometimes song. Djurberg's garishly plumaged creatures are in heat, their sexuality overtly externalized. The bird as an image in literature and art has been traditionally understood as a substitute for male genitalia. In ancient Greece, the winged phallus was a symbol for the god Dionysus. Fertility statues and urns decorated with this symbol were thought to signal his presence and bring sexual gratification. When Freud analyzed his earliest remembered dream, he recalled the image of a group of bird-headed men carrying his mother away. For him, the substitution of a man's head for that of a bird pointed to a nascent Oedipal desire in the dreamer. [16] As Djurberg notes, "Maybe animals are sexual projections." [17]

The flock also exhibits a taxonomic impulse. These birds are not all of the same feather; they are representatives of individual species, however hybrid. The artist's array of static fowl—one of each, as no two sculptures are morphologically identical—evokes didactic displays of taxidermy or, more distantly, ornithological illustration. The theatrical presentation of dead animals—whether in two or three dimensions—has a long tradition in the natural sciences. When French-born naturalist John James Audubon set to documenting each known bird species in America, he worked from dead specimens propped into stylized poses by means of metal wire. The ornithologist's eye is attuned to the outward appearance of things, yet Djurberg's wild flock offers no system, no means to catalogue and explain. Multiple variations abstract one bird from the next in a sequence of frozen moments, or still frames. The attending logic is not evolutionary but rather cinematic.

Just as these sculptures willfully resist mimesis, her animations intentionally lack the technical polish of commercial productions. She works impulsively, often snapping an image of her hand or shadow in the process. Her characters, sometimes attached to wires, lurch convulsively in fits and starts, and close-up shots of her figurines frequently reveal the fingerprints of their maker. If animation conventionally produces an illusion of movement, Djurberg earnestly reveals the trappings of that illusion. In *Camels Drink Water* (2007), for example, two camels happen upon a dehydrated man and decide to carry him to an oasis. To get there, they must limp across the artist's studio from one desert setting to the next, revealing the means of their own production. Djurberg's worlds are porous—tending often to foreground their making through a Brechtian mode of alienation and reflexivity. Berg's scores often serve to amplify the obtrusiveness of this effect.

Whether she is stripping her characters from the comforts of a diegetic world or simply insisting on their materiality, Djurberg forces our attention to oscillate between emotional attachment and the artifice of her constructions. We see her characters as worthy of sympathy, but we also see them as blunt material. In *The Experiment (Greed)* (2009), a young girl seeking refuge from the sexual advances of three lecherous priests is torn apart by another woman, a savage ritual that does not reveal flesh and blood but rather the wire

armature that the artist has used to model her nude figure. The result is a style of animation that lays bare its own making while also tempting us with emotional identification, however unstable.

For all their brevity and deceptive simplicity, Djurberg's films engender a complex tangle of human emotions, modulating rapidly between affection and aggression. A dominant theme running through her work is humankind's twin tendency toward cruelty and compassion. In *Dumstrut* (2006), an idle boy torments a cat by sticking his finger in its anus and swinging it around the room by its tail. Occasional sweet caresses keep the cat from running away or attacking its tormentor. In *Just Because You're Suffering Doesn't Make You Jesus* (2005), a bourgeois woman whips a young man to near death (is he her son? her servant?), an act that causes her to weep sympathetically. In *Florentin* (2004), two sweet girls vie for the attention of their father. When they get overly competitive, he spanks them. The girls retaliate, savagely beating their father with a bat until he cries. Despite the barbarity of these scenarios, we do not look away; this conflict between what the artist calls "the desire to do bad things and being terrified of being evil" proves a riveting circumstance again and again. [18] By bringing savagery and kindness together—two ends of the emotional spectrum—Djurberg is quite literally asking the snake to bite its own tail, as it does in *Deceiving looks* (2011), one of the films presented in *The Parade*.

Regardless of their extreme emotional content, these films do not offer our empathy a stable position, a quality carefully engineered by the artist. In order to produce facial expressions or to choreograph complex movements with her figures, she will first enact these gestures before a mirror. The artist's identification is at first specular, then emotional. "I play all the parts in my films," she says, "so I am both male and female in them. When I started animating, I always saw myself as the victim, but then I realized that I was just as much the torturer. I am the victim and the perpetrator." [19] As her characters develop, she must embody both the abuser and the abused in the creative process. This performance occurs off-camera—between frames—as lived experience in the studio.

Djurberg approaches her narratives in a fragmentary fashion, often beginning simply with a single aspect of character or

story and pursuing it intuitively until it becomes whole. A kind of willful uncertainty drives her. Narratives are free to change direction, as evidenced by the jarring emotional modulations of her films. She proceeds without storyboards or written treatments—maybe just a few notes intimating the affective valences that will take shape—to avoid an overall conception of the work until it is complete. "In the beginning you always think that the idea is so clear," she says, "but as soon as you start working with it, you stumble on difficult things, you have to change it, plus it changes by itself.... What interests me is to follow where the work is going."[20]

In this sense, there is something inherently performative about her practice. The execution of an animation—which occurs painstakingly, frame by frame—becomes an open-ended process of realization and identification, one that absorbs the artist's own lived experience. Robert Gober enacted a similar kind of performance when he commenced *Slides of a Changing Painting* (1982–1983), for which he photographed a succession of compositions painted and scratched out on a board over the course of a year (fig. 7). In a series of slow dissolves, the resulting slideshow presents a deeply subjective memoir, one that signals the artist's longstanding interest in metamorphosis and trauma. Like Gober, Djurberg does not create work that is transparently autobiographical, yet her films always seem to point to the space between film frames, where emotion and intuition dictate creation.

Shifting emphasis away from the storyboard to performance offers us a new perspective on the etiology of Djurberg's work. Generations of artists since the 1960s have explored the limits of the body in its capacity to endure trauma, and none more so than Carolee Schneemann. In her early feminist works of the 1960s, which so radically put her body to the test, she directly challenged American bourgeois decorum with her bacchanalian rituals and endurance tests that often involved naked bodies. Of this "hard, stiff, cold, repressed" society, she writes, "Wild things/wild life confuses them, makes them uneasy: bugs, birds, snakes. Mud, dirt, and dust discourage their control over the world—In this way their insecurity increases; they are guilty, cast-out, and full of anger and impatience. And this obstructs their pleasures."[21] For *Eye Body* (1963), Schneemann erected a stage of painted backdrops in her studio (not unlike Djurberg's)

(fig. 7)

Robert Gober Selections from *Slides of a Changing Painting* 1982–1983

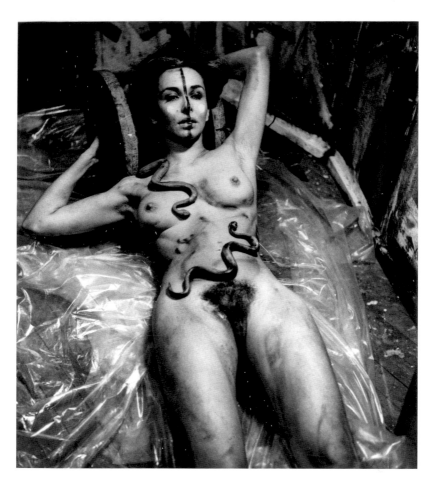

(fig. 8)

Carolee Schneemann Selection from *Eye Body—36 Transformative Actions* 1963

and posed for a photographer with her body covered in paint, string, grease, feathers, and garden snakes (fig. 8). The resulting images—which present the body as a mutable material—are among the most arresting of the early feminist avant-garde.

The result of impulsive, unconscious urges, Schneemann's actions brought abject substances into a close haptic relationship with the body. Her well-known piece, *Meat Joy* (1964), in particular, began as a series of "dream sensation images" that the artist gathered in her notebooks in a state somewhere "between dream and waking" (fig. 9). At the levels of material and affect, the connection to Djurberg's films is self-evident. Schneemann writes, "*Meat Joy* has the character of an erotic rite: excessive, indulgent, a celebration of flesh as material: raw fish, chickens, sausages, wet paint, transparent plastic, rope, brushes, paper scrap. Its propulsion is toward the ecstatic—shifting and turning between tenderness, wildness, precision, abandon: qualities that could at any moment be sensual, comic, joyous, repellent."[22]

Djurberg has noted her interest in the performative actions of the 1960s, in particular those of the Viennese Actionists. Directly confronting the conservatism of post-Fascist Austrian society, the Actionists—Hermann Nitsch, Günter Brus, Otto Muehl, and Rudolf Schwarzkogler—returned the repressed atrocities of World War II in shocking and transgressive acts of mutilation and humiliation. Schwarzkogler, a highly reclusive member of the group, developed the most rigorous theoretical framework for his actions, articulating them as "paintings in motion" and executing them in private, only for a photographer.[23] They were oblique rituals of disintegration and reanimation that, as curator Philippe Vergne has argued, constitute a "reflection on the vulnerability of the human being in the face of alienating forces."[24] For example, Schwarzkogler's sixth and final action presents the artist wrapped in gauze, assuming a mummified puppet form. Wires emerge from a dead chicken's mouth, which the artist then puts into his own in a mute sacrament whereby one might derive energy from the other (fig. 10). With their insistence on dissection, abstraction, and experimentation, Schwarzkogler's performances resulted in the wild dispersion of fluids and bodies, both animal and human. Like those of the Actionists and Schneemann, Djurberg's performances in

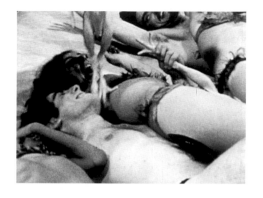

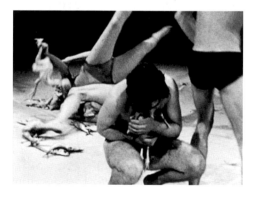

(fig. 9)

Carolee Schneemann Stills from *Meat Joy* 1964/2010

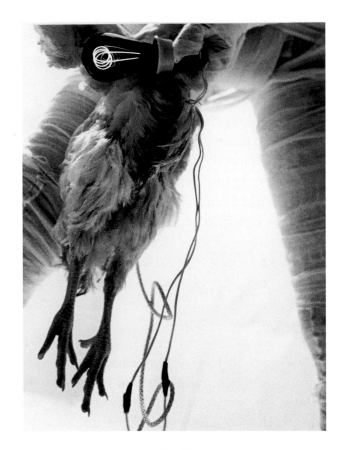

(fig. 10)

Rudolf Schwarzkogler Selection from the portfolio *Actions, Vienna 1965/66* 1975–1982

the studio exhibit a similar tendency. It is in their compulsion toward entropy that her films exert their politics, for dismemberment always happens at the hands of others.

Surrounded by a cavalcade of birds, Djurberg's films for *The Parade* imagine the social realm stripped bare—its abstractness exposed for all to see. In a world increasingly marked by networks of virtual connection, these films give form to profound feelings of isolation and alienation. While many of her earlier works have centered on recognizable domestic settings, she has more recently moved away from such specificity of period and place, opting instead for anytime and anywhere. Against gradient backdrops that suggest Color Field paintings, these characters exist in a state of exemption. Their hermetic universes have no rule of law. Punishments are meted out not with any recourse to justice but rather as an effect of instinct, of base desire. According to ancient Roman law, when a man broke an oath, his violation meant that he became the property of the gods, no longer fit for human society. He was deemed a *homo sacer*, or cursed man, one who could be killed by anyone but who was not fit for religious sacrifice.

Elsewhere in his writings, Agamben has used this figure to distinguish between the political life of citizens and the "bare life" of bodies. [25] The *homo sacer* is cast out of the community and stripped of his civic qualifications. He is no longer a citizen; all that remains is a human creature. The protagonists of Djurberg's five films have similarly been cast off, subjected to the cruelties of the natural landscape or extended captivity. For the artist, this notion manifests itself visually in the supine figure. The opening shot of *I wasn't made to play the son* (2011) tracks across a purple woman lying on the ground face up. Vulnerable, she is subjected to our gaze before she is torn apart at the hands of two men she loved as children. Similarly, the camera tracks across the exposed body of the defenseless man-child in *Open window (2011)*. We see him squirm, tormented by his dreams, before he awakens and finds himself the plaything of an agitated, captive bird. These are not active agents, but rather passive receptors. The boy sucks his thumb and rocks back and forth. The woman pleads for mercy but cannot move in self-defense.

This notion of "bare life" is also manifest in the artist's narrational voice. Since her films intentionally lack spoken dialogue,

her characters are mute. They speak only through facial expression and gestural histrionics. In *Deceiving looks* and *I am saving this egg for later* (both 2011), humans and animals attempt to communicate with masks. When her characters do utter words, they are dissociated from their voice. In *I wasn't made to play the son*, Djurberg scrawls their phrases on her backdrops, without clearly indicating their origin. As Agamben writes, "Subjectivity is nothing other than the speaker's capacity to posit him or herself as an ego, and cannot in any way be defined through some wordless sense of being oneself, nor by deferral to some ineffable psychic experience of the ego, but only through a linguistic I transcending any possible experience." [26] In this sense, Djurberg's films not only give form to an experience of being without language; they also dramatize subjectivity without ego. Agamben theorizes this condition as "infancy" (the term is not meant to be understood in a developmental sense). For him, infancy is a state of potentiality—the essence of experience. It is a facet of our subjectivity we never leave behind. It stays with us as a constant reminder that language is not inborn; we receive it from outside. In her process of narration, Djurberg locates herself in this "outside" position as puppeteer, endowing her figures with urges, voices, and behaviors, however external and contingent these impulses remain.

Not unlike her sculptures, Djurberg's recent films are best understood together as a flock. Presented not as a sequence of episodes, but rather as interwoven scenarios that overlap and inform each other, they resist stable identification and easy interpretations. Here, the artist has begun to experiment more expansively with narration as a spatial phenomenon. As we wander through *The Parade*, we process these films in fragments and fleeting impressions amidst an intimidating sculptural scenario insistent on returning our gaze. No single film holds the key to the others; they each refract in a matrix of echoes and correspondences, fears and desires. Figures, motifs, settings, and scenarios migrate from one narrative to the next. A captive bird in one film is defeathered in another. Postures, actions, and expressions repeat. Masks serve to disguise intent on multiple occasions, and behaviors oscillate between aggression and affection. No single element remains fixed; Djurberg's looping parade of films is insistently, neurotically recursive.

The same may be said for Berg's dark, atmospheric soundtrack, which suffuses the entire installation. With it, he has begun to explore a new relationship between spectator, film, and installation. For the first time on this scale, he has devised his score using surround sound, mapping each audio channel to a specific film. Simultaneously composing for individual narratives and the group, his composition also reflects the complicated social dynamics of the flock. Each film emanates its own unique soundtrack, yet together they form a "schizophrenic" chorus, which Berg brings precariously close to "the brink of chaos." [27] As one moves through the space of the exhibition, the soundtrack of each film bleeds into the next, creating a soundscape designed to envelop the viewer.

More so than other such moving-image installations today, we navigate the objects, images, and sounds of *The Parade* freely, obeying only the peregrinations of our own pleasure, with very little regard for what Roland Barthes has called the "integrity of the text." [28] As we are often reminded, such is the condition of spectatorship in museums today, which are now so thoroughly saturated with moving images. We do not sit immobilized as in a movie theater, and the image is no longer frozen as in a picture frame. Our experience is marked by an overlapping of time—the duration of cinematic images and the duration of our wandering—and rarely do the two ever coincide perfectly. [29] With *The Parade*, Djurberg and Berg offer a further complication to this ubiquitous sense of dislocation—a tendency toward surface and depth, attraction and repulsion, specularity and immersion, resulting in a mode of looking that is as impulsive and subjective as the work itself. Theirs is an environment capable of returning us to an untutored state of looking, to the wildness of our own perception.

1 For a thorough discussion of the expression theory of art, see Noël Carroll, "Art and Expression," in *Philosophy of Art* (London: Routledge, 1999), 59–106.

2 Ludwig Wittgenstein, *Culture and Value*, ed. and trans. Peter Winch (Chicago: University of Chicago Press, 1984), 37e–38e. For more on Wittgenstein's conception of animality, see Marcus Steinweg, "Wittgenstein's Animal," trans. Gerrit Jackson, in *Inaesthetics 2: Animality*, eds. Wilfried Dickhoff and Marcus Steinweg (Berlin: Merve Verlag, 2011), 35–41.

3 Giorgio Agamben, "What Is the Contemporary?" in *What Is an Apparatus? and Other Essays*, trans. David Kishik and Stefan Pedatella (Stanford, California: Stanford University Press, 2009), 44.

4 Quoted in Hans Berg and Kathrin Meyer, "Sound Creatures: An E-mail Conversation," in *Snakes Knows It's Yoga: Nathalie Djurberg with Music by Hans Berg* (Nürnberg, Germany: Verlag für Moderne Kunst, 2010), 21.

5 Quoted in Sanneke Huisman, "The Sweet and the Gruesome: Interview with Nathalie Djurberg and Hans Berg," *Metropolis M*, March 15, 2011, http://www.metropolism.com/features/the-sweet-and-the-gruesome/.

6 Quoted in Stefano Casciani, "Interview 10: Nathalie Djurberg and Hans Berg," *Domus* 944 (February 2011): 40.

7 Jacques Lacan, "What Is a Picture?" in *The Four Fundamental Concepts of Psychoanalysis*, ed. Jacques-Alain Miller, trans. Alan Sheridan (New York: W. W. Norton, 1978), 114, 115.

8 Quoted in Huisman.

9 See, for example, Sigmund Freud, *Jokes and Their Relation to the Unconscious*, trans. and ed. James Strachey (New York: W. W. Norton, 1963), 159–180.

10 Quoted in Grady Turner, "Yayoi Kusama," *Bomb* 66 (Winter 1999): 63.

11 See Lynn Zelevansky, "Driving Image: Yayoi Kusama in New York," in *Love Forever: Yayoi Kusama, 1958–1968* (Los Angeles: Los Angeles County Museum of Art, 1998), 15.

12 Quoted in Ali Subotnick, "Nathalie Djurberg: Naughty by Nature," *Flash Art* 251 (November–December 2006): 83; and Casciani, 41.

13 Quoted in Turner, 65.

14 See Michael Nickel, "A Work in Progress or, Necessity Is the Mother of Invention: The Making of *A Procession in Honor of Aesthetic Progress: Objects to Theoretically Wear, Carry, Pull, or Wave*," trans. Suzanne S. Zuber, in *Paul Thek: Diver, a Retrospective* (New York: Whitney Museum of American Art, 2010), 96–99.

15 George Orwell, "The Lion and the Unicorn: Socialism and the English Genius," in *My Country Right or Left, 1940–1943*, eds. Sonia Orwell and Ian Angus (Boston: Nonpareil Books, 2004), 61–62.

16 See Sigmund Freud, *The Interpretation of Dreams*, trans. and ed. James Strachey (New York: Avon Books, 1965), 622–623.

17 Quoted in Germano Celant, "Germano Celant—Nathalie Djurberg: Interview," *Nathalie Djurberg: Turn Into Me* (Milan: Fondazione Prada, 2008), 134.

18 Quoted in Subotnick, 82.

19 Quoted in Celant, 108.

20 Quoted in Casciani, 39.

21 Carolee Schneemann, *More Than Meat Joy: Complete Performance Works and Selected Writings*, ed. Bruce McPherson (New Paltz, New York: Documentext, 1979), 59.

22 Carolee Schneemann, *Imaging Her Erotics: Essays, Interviews, Projects* (Cambridge, Massachusetts: MIT Press, 2002), 61.

23 See Malcolm Green, ed., *Brus Muehl Nitsch Schwarzkogler: Writings of the Vienna Actionists* (London: Atlas Press, 1999), 199.

24 Philippe Vergne, "Rudolf Schwarzkogler," in *Bits & Pieces Put Together to Present a Semblance of a Whole: Walker Art Center Collections*, eds. Joan Rothfuss and Elizabeth Carpenter (Minneapolis, Minnesota: Walker Art Center, 2005), 503.

25 See Giorgio Agamben, *Homo Sacer: Sovereign Power and Bare Life*, trans. Daniel Heller-Roazen (Stanford, California: Stanford University Press, 1998).

26 Giorgio Agamben, *Infancy and History: Essays on the Destruction of Experience*, trans. Liz Heron (London: Verso, 1993), 45.

27 Hans Berg, e-mail correspondence to the author, July 6, 2011.

28 See Roland Barthes, *The Pleasure of the Text*, trans. Richard Miller (New York: Hill and Wang, 1975).

29 See Boris Groys, "Comrades of Time," in *e-flux journal: What Is Contemporary Art?* (Berlin: Sternberg Press, 2010), 22–39.

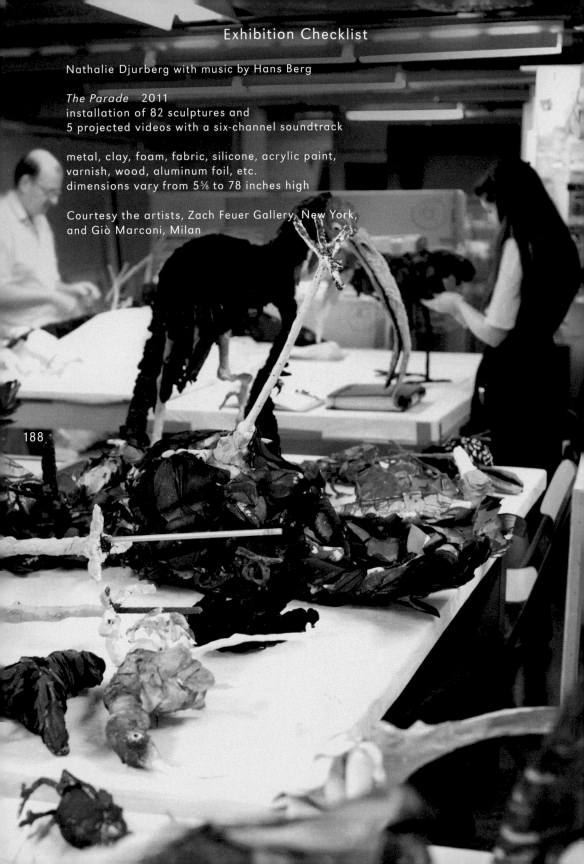

Nathalie Djurberg with music by Hans Berg

The Parade 2011
installation of 82 sculptures and
5 projected videos with a six-channel soundtrack

metal, clay, foam, fabric, silicone, acrylic paint,
varnish, wood, aluminum foil, etc.
dimensions vary from 5⅝ to 78 inches high

Courtesy the artists, Zach Feuer Gallery, New York,
and Giò Marconi, Milan

188

Deceiving looks
digital video animation (color, sound);
5:58 minutes
(pages 35–47)

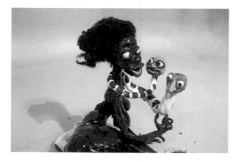

Open window
digital video animation (color, sound);
5:54 minutes
(pages 111–123)

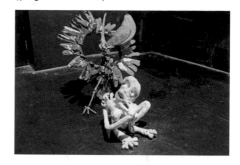

I wasn't made to play the son
digital video animation (color, sound);
6:19 minutes
(pages 49–61)

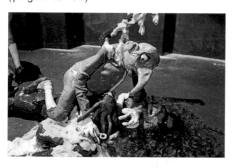

Bad eggs
digital video animation (color, sound);
6:01 minutes
(pages 125–137)

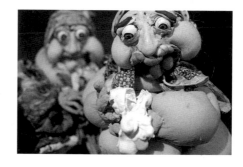

189

I am saving this egg for later
digital video animation (color, sound);
5:57 minutes
(pages 79–91)

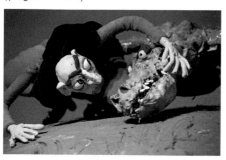

About the Artists

Nathalie Djurberg was born in Lysekil, Sweden, in 1978. She studied art at Folkuniversitetet (1994–1995) and Hovedskous Art School (1995–1997), both in Gothenburg, Sweden, before receiving her MFA from Malmö Art Academy in 2002. She has honed a distinctive style of stop-motion animation since 1999, when she first taught herself how to make films. Using the pliability of clay, her handcrafted narratives explore the vicissitudes of revenge, lust, submission, gluttony, and other primal emotions in wry allegories of human behavior and social taboo. Increasingly, her practice has blurred the cinematic and the sculptural in immersive environments that integrate moving images and sound with related set pieces. She currently lives and works with Hans Berg in Berlin.

Born in Rättvik, Sweden, in 1978, Hans Berg is a Berlin-based techno and house music producer. He is a self-taught musician who began playing the drums in punk and rock bands at the age of fourteen. A year later, he started creating electronic music—which he has made ever since—when he purchased his first synthesizer and sampler. In addition to his many live concerts, Berg also has an extensive discography with releases by Kant Recordings, Tsunami Productions, and other labels. He met Djurberg in Berlin in 2004, and since then he has composed the music for all of her films and installations.

The artists' collaborations have been featured widely in solo and group exhibitions around the world. Most notably, in 2009 they presented their installation *The Experiment* in *Making Worlds* at the 53rd Venice Biennale, for which Djurberg was awarded the prestigious Silver Lion for a Promising Young Artist. Their other solo exhibitions include Kunsthalle Wien, Vienna (2007); Kunsthalle Winterthur, Switzerland (2007); Fondazione Prada, Milan (2008); Hammer Museum, Los Angeles (2008); Frye Art Museum, Seattle (2009); OMA Prada Transformer, Seoul (2009); kestnergesellschaft, Hannover (2010); Natural History Museum, Basel (2010); Wexner Center for the Arts, Columbus, Ohio (2011); Museum Boijmans Van Beuningen, Rotterdam (2011); and Camden Arts Centre, London (2011).

Nathalie Djurberg and Hans Berg would like to thank Eric Crosby, Dean Otto, Pascal Strauss, Dahni Strauss, Arielle Öster, Zach Feuer Gallery, and Galleria Giò Marconi.

Reproduction Credits

Unless otherwise noted, all photos by Cameron Wittig

Pages 37–47, 51–61, 81–91, 113–123, 127–137, 189
Photos: Nathalie Djurberg

Page 162
Guillaume Apollinaire, "The Peacock," from *Bestiary: or The Parade of Orpheus*, trans. Pepe Karmel (Jaffrey, New Hampshire: David R. Godine, 2000), 54. The poem appears as an epigram to the catalogue essay.

Page 167
Photos: Hans Berg, courtesy Zach Feuer Gallery, New York, and Giò Marconi, Milan

Page 168 (top)
Collection Walker Art Center, Minneapolis; Gift of Fondazione Lucio Fontana, 1998

Page 168 (bottom)
Courtesy Walker Art Center Archives, Minneapolis Photo: Eric Sutherland

Page 171
©Yayoi Kusama and courtesy Gagosian Gallery, New York/Ota Fine Arts, Tokyo

Page 172
Courtesy Walker Art Center Archives, Minneapolis Photo: Eric Sutherland

Page 178
Collection Walker Art Center, Minneapolis; T. B. Walker Acquisition Fund, 1992 ©Robert Gober

Page 179
Courtesy the artist and P.P.O.W Gallery, New York Photo: Erró
©Carolee Schneemann

Page 181
Collection Walker Art Center, Minneapolis; T. B. Walker Acquisition Fund, 2010 Courtesy the artist and Electronic Arts Intermix (EAI), New York ©Carolee Schneemann

Page 182
Collection Walker Art Center, Minneapolis; Justin Smith Purchase Fund, 2001 Courtesy Galerie Krinzinger, Vienna

192